IMAGES
of America

SAN FRANCISCO'S
FINANCIAL
DISTRICT

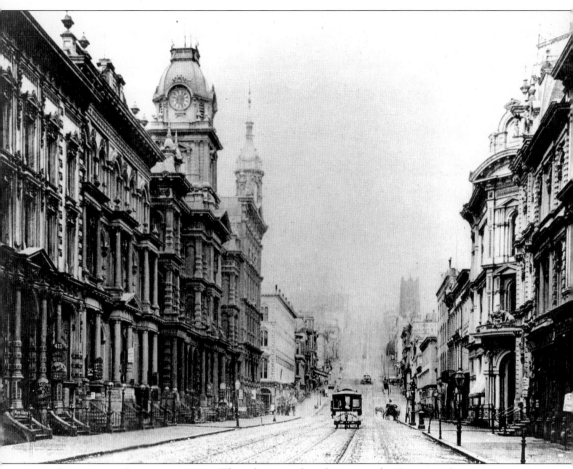

CALIFORNIA STREET, C. 1879. This photograph, taken near the Sansome Street intersection, shows the ornate buildings that once lined California Street. The cable car line that travels this street today is a remnant from this period. Here it is seen amidst its original surroundings. (Courtesy of the San Francisco History Center, San Francisco Public Library.)

Compliments
of

THE RITZ-CARLTON CLUB® AND RESIDENCES
SAN FRANCISCO

A private residence club blending
The Ritz-Carlton Hotel Company's
history of class
with the city of San Francisco's
classical history.

The art of luxury and hospitality
within an exclusive
community of uncompromised
privilege and prestige.

IMAGES
of America

SAN FRANCISCO'S
FINANCIAL
DISTRICT

Christine Miller

Published by Arcadia Publishing
Charleston SC, Chicago IL, Portsmouth NH, San Francisco CA

Printed in Great Britain

Library of Congress Catalog Card Number: 2005929101

For all general information contact Arcadia Publishing at:
Telephone 843-853-2070
Fax 843-853-0044
E-mail sales@arcadiapublishing.com
For customer service and orders:
Toll-Free 1-888-313-2665

Visit us on the internet at www.arcadiapublishing.com

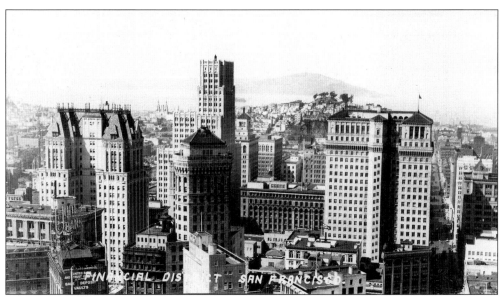

EARLY SKYLINE. This undated postcard shows the cluster of buildings that dominated the skyline of the Financial District before modern high-rises.

CONTENTS

ACKNOWLEDGMENTS

Many people gave of their time and resources to help me with this book. First, I would like to thank my mother, Betty Miller, for the multitude of ways in which she helped me with this project. I would also like to thank my employer Morgan, Lewis and Bockius LLP and my coworkers, Les Bonus, Carol Evans and Heather Hay. Special thanks to Lorri Ungaretti for all of her help as well.

I am grateful to the staff of the History Center of the San Francisco Main Library but would especially like to thank Pat Akre and Richard Marino. My thanks also to the wonderful Joe Evans of the California Historical Society and to their photographer Philip Adam. Special thanks to Kristin Satzman Photography for the restoration work done on the photographs of the San Francisco Bar Pilots. Thanks to John Garvey for showing me the airplane spotter photographs. Thanks to Zenobia and all of the ladies in the Mission Dolores gift shop for their support. Thanks to current Mission Dolores curator Andy Galvan and to former curator Brother Guire Cleary. La paz y bien! Thanks also to Don Eichelberger of the San Francisco Green Party.

My thanks to all of the people and the companies that gave their support to this project. Thanks to Crystal Rockwood, Kirsten Millen and to Jim Joannides of Pillsbury Winthrop Shaw Pittman LLP; Golden Gate University; Lonnie Ball and Kenny Levin of the San Francisco Bar Pilots Association; Carmen Roberson of Gump's; Brian Swanson of Pacific Gas and Electric Company (Go Giants!); John Kozero of Fireman's Fund Insurance Company; Renee Roberts of the Palace Hotel; Katie Madden of the Bank of California; Ellie Walsh of ABM Industries, Inc.; Mike Buich of the Tadich Grill; Bob Schneider of Bechtel Corporation; Lynn Downey of Levi Strauss and Company; Susan Savage of Heald College; Mary Currie of the Golden Gate Bridge Highway and Transportation District; David Mendoza of the Bank of America; Inez Cohen and Liz Paxton of the Mechanics' Institute Library; Thanks to Ken Cornwell of the Glenborough Realty Trust for the use of the Rincon Annex murals in this book. Thanks to Henry Alker of the Southport Land and Commercial Company and to Lew Harper of Hoyt Shepston. My thanks to photographer Bob David for his help and for allowing me to use the Herb Caen photograph. Thanks also to photographer Peter Maiden. Thanks to you all!

INTRODUCTION

The Financial District is one of San Francisco's earliest and most dynamic neighborhoods. In this book, the area bounded by Market Street, Kearny Street, Broadway Avenue, and the Embarcadero is considered the Financial District. This neighborhood began as a village on Yerba Buena Cove in 1835, separate from the only two other establishments in town, the Mission Dolores and the Presidio. It has remained the business center of San Francisco since that time. And despite the sweeping changes the neighborhood has been through, from earthquakes to fires, it is still home to businesses that date back to its very earliest days.

The early history of the Financial District is connected to that of the Mission de San Francisco de Asis (the Mission Dolores), which was the business center of San Francisco from 1776 to 1835. The events that led to the settlement of San Francisco by the Spanish began in 1542 when Juan Rodriguez Cabrillo explored the Pacific Coast and claimed California for Spain. The Spanish chose not to occupy the area until many years later when King Carlos III appointed Jose de Galvez as visitor-general of New Spain (Mexico) and gave him the responsibility of protecting the boundaries of the empire. Russian encroachment into Alaska and the North American coast was considered threatening to their claim on California, and Galvez decided that establishing a presence at Monterey would be the best way to begin permanent settlement.

The mission system used in New Spain to introduce the native peoples to Spanish culture was to be expanded into California. On July 16, 1769, the first California mission was established in San Diego. Shortly afterwards, a Spanish expedition led by Gaspar de Portola left San Diego to survey the northern part of California and find the Monterey Bay. Their search for Monterey was based on a description of the landscape form Sebastian Vizcaino's voyage along the California coast in 1602. Not realizing that they had passed it, the Portola expedition entered the San Francisco Bay region in October of 1769. Their arrival signaled the beginning of Spanish expansion into the area. The first recorded contact between the tribal people of the San Francisco Bay and the Spanish occurred on October 22, 1769, when Portola's scouting party encountered a group of Quiroste Ohlone at Point Ano Nuevo.

Although voyages commanded by Sir Francis Drake (1579), Sebastian Rodriguez Cermeno (1595), and Sebastian Vizcaino (1602–1603) had traveled the California coast, it was not until Portola's scouting party viewed the San Francisco Bay from a peak in the area now known as Sweeney Ridge in Pacifica that the San Francisco Bay was officially "discovered" on November 1, 1769.

In the following years, several land expeditions followed Portola's into the Bay Area. On August 8, 1775, the *San Carlos* became the first ship to sail into and survey the San Francisco Bay. That same year, an expedition led by Capt. Juan Batista de Anza left Tubac, Mexico, with a group of over 200 settlers to colonize Northern California. In March 1776, Anza and Fr. Pedro Font traveled into the San Francisco region to choose the locations for a mission and a presidio. On June 27, 1776, Lt. Jose Joaquin Moraga and Fr. Francisco Palou followed with the first group of settlers and soldiers. Along with them came 1,000 head of cattle, modern tools, and weaponry. They founded

the Mission de San Francisco de Asis, more popularly known as the Mission Dolores, which then became the sixth of California's 21 missions.

Prior to the arrival of the Spanish, San Francisco was the home of Ohlone Indians who resided in several seasonal villages. The Mission Dolores was established near one of these villages and had a dramatic effect on the Ohlone's culture and population. The mission was built by Ohlone labor, and in return, they received food, clothing, housing, and religious instruction. In theory, the Ohlone Indians owned the mission and its lands and shared the profits of their labor communally. However, the mission system had been imposed on them with little alternative, and they ultimately never received the land they had been told was theirs. Living conditions at the mission spread diseases, and the Ohlone population decreased drastically. Those who attempted to leave were brought back by the soldiers from the Presidio. The intersection of two cultures that took place at the Mission Dolores had a devastating impact.

During the Spanish era, the Mission Dolores was the primary source of industry in the area. Trading with foreign vessels was illegal, but early in the 19th century, changes took place that opened commerce in San Francisco. In 1810, the War of Revolution stopped the supply ships to the mission and the Presidio from Mexico; that necessitated trade with Russian, English, and American ships. In 1821, Mexico became independent of Spain and California eventually became part of the new Mexican Republic. Spanish trading laws were abandoned and commerce grew.

It was at this time that the business center of San Francisco moved towards the waterfront and the history of the Financial District begins. The little trading community there grew modestly until 1848–1849, when the gold rush opened San Francisco to the world and its population exploded. The gold rush was followed by silver strikes in Nevada in the 1860s and 1870s that generated the fantastic wealth that built much of the Financial District.

Today the Financial District is a world-class business district built upon the filled-in shores of Yerba Buena Cove and along the lines laid out by some of its earliest settlers. On the outside of many of the Financial District's buildings are plaques and markers that speak of this neighborhood's history. Inside of those buildings, the history of earlier San Franciscans survives in the businesses and institutions that have made this neighborhood their home for well over 100 years.

One

Early History of the
Financial District

The initial business center of San Francisco was the Mission Dolores, the primary source of industry between 1776 and 1835. San Francisco existed as an isolated Spanish settlement until the Mexican government assumed control in 1835 and trade was opened. That same year, Capt. William Antonio Richardson built the first residence on Yerba Buena Cove. The cove, which has long since been filled in and built upon, stretched from what is now the intersection of Spear and Folsom Streets to Broadway Avenue; the beach ran along what is now Montgomery Street. Richardson established a small retail trade and acted as customs collector for the port. In 1836, Jacob Leese built a house there as well, and soon others followed. Within a decade, there were about 800 people living in the trading settlement of Yerba Buena. The original streets were laid out by Jean Jaques Vioget in 1839, and later, in 1846, Jasper O'Farrell laid out Market Street parallel to the road to the mission. The name was officially changed from Yerba Buena to San Francisco in 1847 by a proclamation issued by the chief magistrate and published in the first local newspaper, the *California Star*.

The early history of the Financial District is remembered on many historical markers around the Portsmouth Square area. There are no buildings from this era in the Financial District. The Mission Dolores at Sixteenth and Dolores Streets remains the oldest intact building in San Francisco, and some of the Financial District's early history is preserved there. The San Francisco Bar Pilots Association, founded by Captain Richardson in 1835, is the oldest continuously operating business in California and is still located within the Financial District.

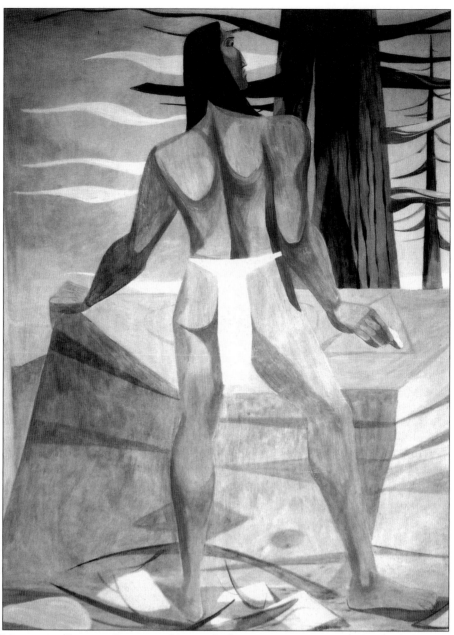

A California Indian Creates. (Anton Refregier. Case-in-tempera. Rincon Annex, San Francisco 1946–1948.) "I shman colma carac yonahiacho isha. Hachche ahmush owahto harwec ivshah" translates to "Sun, earth, sky, village, friend, alive. We eat, drink, sing, and dance." These brief words of the native language of the aboriginal inhabitants of San Francisco come from a public marker on the first site of the Mission Dolores. At the time of the arrival of the Spanish Empire, San Francisco was populated by less than 200 Ohlone Indians who resided in several small seasonal villages. The Ohlone people hunted animals and collected the plant foods around them. They used stone and bone tools, wove baskets, and made simple canoes out of reeds. They spoke the Ohlonean language, as did the local tribes to the south and the east with whom they intermarried. (Christine Miller photograph.)

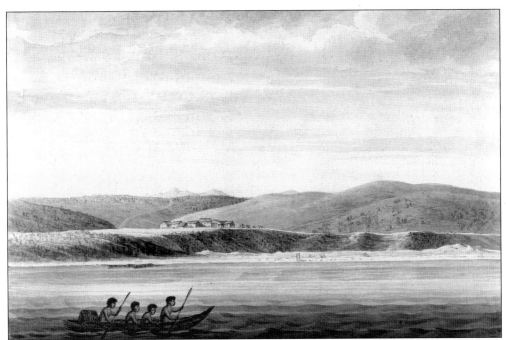

VIEW OF THE SPANISH ESTABLISHMENT OF ST. FRANCISCO IN NEW CALIFORNIA, 1806. George Heinrich von Langsdorff's sketch is considered the earliest known drawing of San Francisco and the Presidio. It shows the settlement as seen from the ship *Juno*, which had sailed into San Francisco searching for food supplies to bring back to Sitka, Alaska. (Courtesy of the Bancroft Library, University of California, Berkeley.)

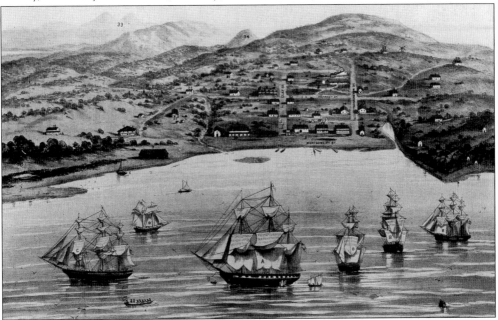

VIEW OF SAN FRANCISCO, FORMERLY YERBA BUENA, 1846–1847. This illustration shows what the Financial District looked like before the discovery of gold. Note that the original shoreline runs along Montgomery Street. (Courtesy of the California Historical Society.)

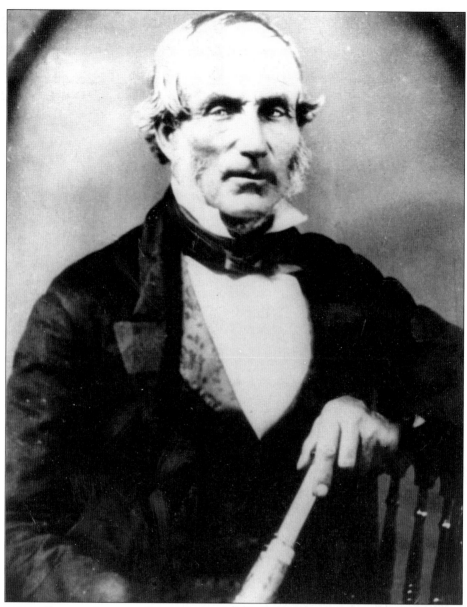

CAPTAIN WILLIAM ANTONIO RICHARDSON (1795–1858), FOUNDER OF THE SAN FRANCISCO BAR PILOTS. William Richardson was a key figure in the early history of the Financial District. He arrived in San Francisco as first mate on the whaling ship *Orion* but, due to conflicts, jumped ship. He married a daughter of the commander of the Presidio and then briefly moved to Southern California. They returned to San Francisco in June 1835 and became the first residents of the village of Yerba Buena. Captain Richardson, for whom Richardson Bay is named, was also the founder of the San Francisco Bar Pilots in 1835. The bar pilots board ships upon their arrival at the Golden Gate and navigate them through the waters of San Francisco Bay. The service of the pilots was considered so crucial that the 1849 California legislature, in one of its first acts, put the bar pilots under state authority. They are now the oldest business in San Francisco as well as the oldest continuously operating enterprise in California. (Courtesy of the San Francisco History Center, San Francisco Public Library.)

AMERICAN OCCUPATION OF YERBA BUENA, JULY 9, 1846. On July 9, 1846, Captain Montgomery landed in Yerba Buena on the USS *Portsmouth* and marched to the plaza, where he raised the American flag, read a proclamation, and took possession of the town in the name of the United States—with no resistance. (Christine Miller photograph, 2005.)

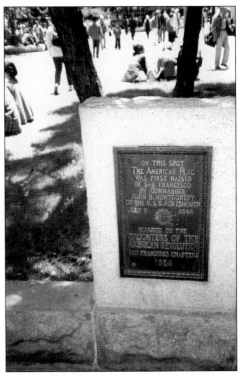

SAM BRANNON AND THE CALIFORNIA STAR. (Anton Refregier. Case-in-tempera. Rincon Annex, San Francisco 1946–1948.) On July 31, the ship *Brooklyn* arrived in Yerba Buena with a group of 200 Mormons seeking a new territory in which to establish themselves. Their leader, Sam Brannon, published the first newspaper in San Francisco, the *California Star* on January 9, 1847. (Christine Miller photograph, 2005.)

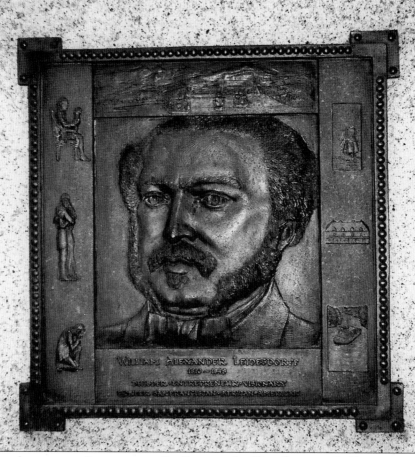

WILLIAM ALEXANDER LEIDESDORFF JR. PLAQUE AT THE CORNER OF LEIDESDORFF AND SACRAMENTO STREETS. William Alexander Leidesdorff, born in the Virgin Islands, was the son of Danish citizen and Anna Marie Sparks, a woman of African ancestry. In 1841, he sailed into Yerba Buena and quickly became one of its most impressive citizens. In 1845, he became United States vice-consul for the Mexican government in California, and as such, the first African American diplomat in the United States. In 1846, he was actively involved in the Bear Flag Revolt and helped secure California for the United States. For this, he is considered the "African Founding Father of California." Leidesdorff was at the center of social and political life in Yerba Buena. He built the first hotel and first commercial shipping warehouse. He served on the town council, was elected city treasurer, served on the local school board, and donated land for the first public school in San Francisco. (Christine Miller photograph, 2005.)

Two

THE GOLD RUSH

Between 1848 and 1859, San Francisco made a rapid, difficult transition from an isolated village to bustling city. The Treaty of Guadalupe Hidalgo ended the war with Mexico in 1848 and California became part of the United States just prior to one of the most important events in America's history, the California gold rush. A mass migration of people to San Francisco from around the world brought entrepreneurs and businesspeople who established companies that continue to this day. The earliest of these gold rush era businesses are Boudin Sourdough Bakery, the Marine Exchange (formerly the Merchants Exchange), Rathbone, King, and Seeley Insurance Services, and the Tadich Grill restaurant, which were all established in 1849. The firm of Hoyt Shepston, a custom-house brokerage was established in 1850 as well as funeral directors Halsted, N. Gray-Carew, and English. Phoenix Day, manufacturer of light fixtures, was also established in 1850. In 1851, Haas Brothers, a wholesale liquor company, was established. Shreve and Company, Ghirardelli Chocolate Company, and Wells Fargo and Company were all established in 1852 as was Tobin and Tobin, the oldest law firm in California. In 1853, Bulloch and Jones menswear and Levi Strauss and Company were both founded. The Borel Bank and Trust Company was established in 1855.

Other notable institutions founded in the Financial District during the gold rush era are the chamber of commerce in 1850, St. Patrick's Church in 1851, and Old St. Mary's in 1854. The YMCA opened its San Francisco branch in 1853, and the Mechanics' Institute was founded in 1855.

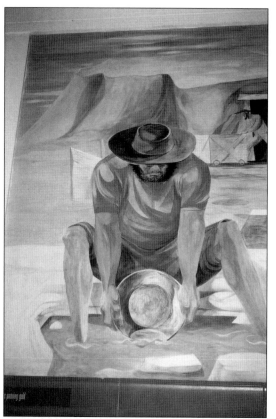

MINERS PANNING FOR GOLD. (Anton Refregier. Case-in-tempera. Rincon Annex, San Francisco 1946–1948.) Although small amounts of gold had already been discovered in California, it wasn't until the discovery of gold in January 1848 at John Sutter's mill in Coloma that the opportunities in California became apparent. (Christine Miller photograph, 2005.)

THE FORTY NINERS. (Anton Refregier. Case-in-tempera. Rincon Annex, San Francisco 1946–1948.) News of the discovery of gold at Sutter's Mill spread but did not immediately start a rush. In May 1848, Sam Brannon returned to San Francisco from Coloma brandishing gold samples and announcing that there was gold on the American River. The town emptied out and the rush was on. (Christine Miller photograph, 2005.)

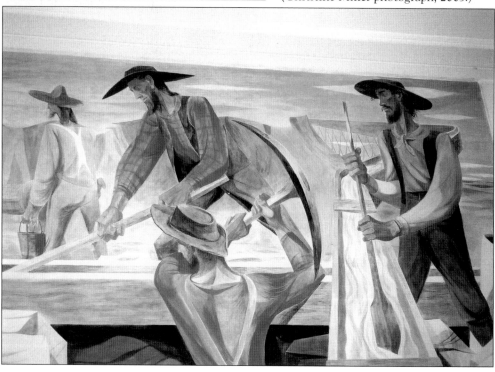

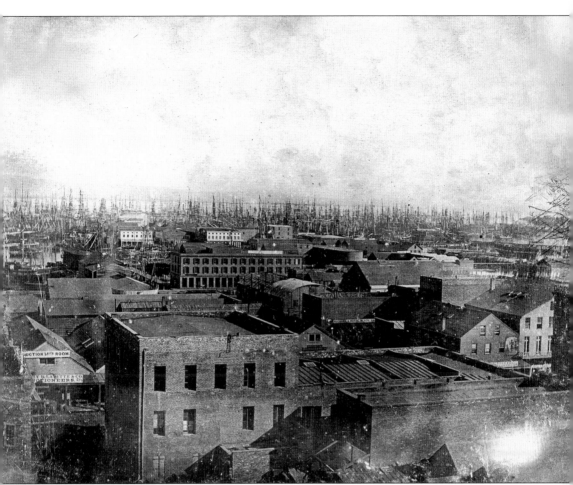

OLDEST PHOTOGRAPH OF SAN FRANCISCO. The immense migration of people into San Francisco from around the world reflected political conditions going on elsewhere at the time. There were two available routes to San Francisco from the East. The overland route left from St. Joseph, Missouri, in April and arrived in October or November. The sea route required going around tip of South America and took several months. The faster route was across the Isthmus of Panama or through Nicaragua, requiring several different modes of travel before reaching the ships on the other side. This photograph, taken in 1850, is considered the oldest known photograph of San Francisco. (Courtesy of the San Francisco History Center, San Francisco Public Library.)

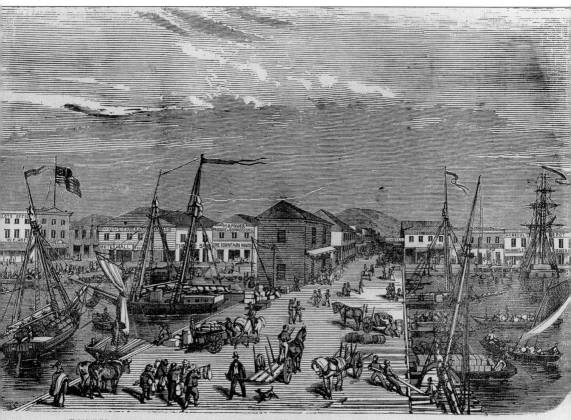

PUBLISHED BY CHARLES P. KIMBALL, NOISY CARRIER'S PUBLISHING HALL.

LONG WHARF, SAN FRANCISCO, CALIFORNIA.

LONG WHARF, AT THE FOOT OF COMMERCIAL STREET. (Published by Charles P. Kimball, Noisy Carrier's Publishing Hall.) In November 1851, Adolph Sutro, later to become mayor of San Francisco, wrote this description of Long Wharf in a letter: "This long wharf or central wharf is built far out into the water; 2/3 of the length has houses on it which are built on piles; one can go in a boat underneath it. In the houses on this long street there is a drink-shop, a restaurant or auction store and the whole day long there is strife and bustle there greater than you find in South Street, New York. There are at least 20 night auctions. Sometimes in the evening I pass by this place and find it much more amusing than going to the theater. At one of these auction stores they sell gold watches made out of brass, at another, one is trying sell a penknife, and notwithstanding the fact that they are all frauds, they get many customers to buy." (Courtesy of the California Historical Society.)

18

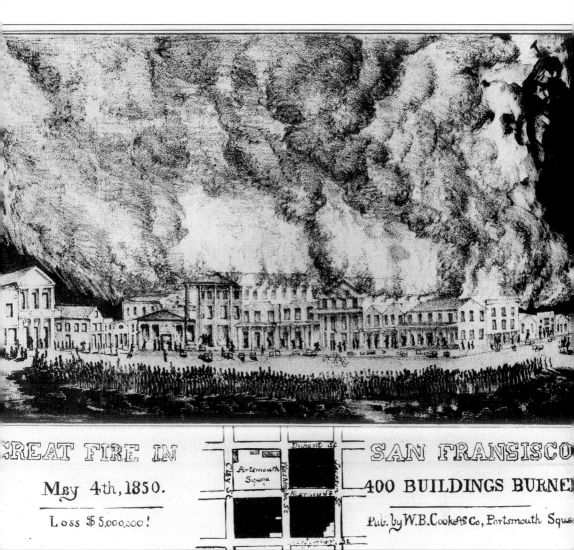

THE GREAT FIRE ON MAY 4, 1850. (Published by W. B. Cooke and Company, Portsmouth Square.) The primarily wooden, poorly constructed buildings of the gold rush era were easily susceptible to fire. Fuel and heat sources of the time contributed to that danger. Six immense fires occurred, between Christmas Eve 1849 and June 1851, that destroyed vast areas of the business district. Not long after the first fire, a volunteer fire company was formed and many more followed. The city did not have a municipal fire department until 1867 and until then the volunteer fire companies were a powerful influence in the city. The fire scene in this illustration took place near Portsmouth Square in the vicinity of Montgomery, Kearny, Clay, Jackson, and Dupont (now Grant) Streets. Over 400 buildings were burned at a loss of $5,000,000. (Courtesy of the California Historical Society.)

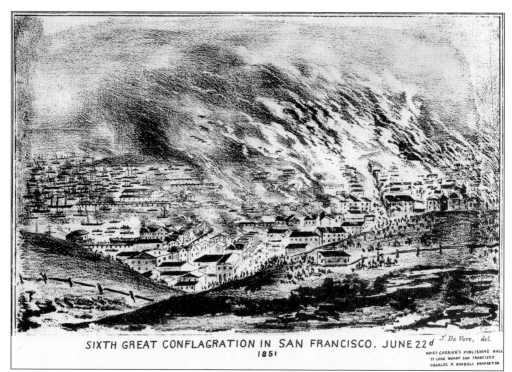

SIXTH GREAT CONFLAGRATION IN SAN FRANCISCO. JUNE 22ᵈ
1851

J. De Vore, del.

NOISY CARRIER'S PUBLISHING HALL
77 LONG WHARF SAN FRANCISCO
CHARLES P. KIMBALL PROPRIETOR

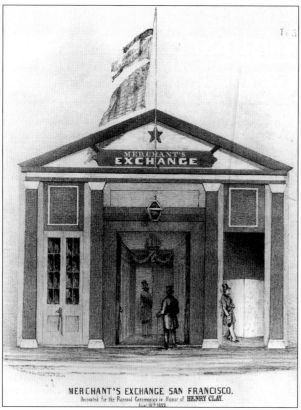

MERCHANT'S EXCHANGE SAN FRANCISCO.
Decorated for the Funeral Ceremonies in Honor of HENRY CLAY.
Aug. 10ᵗʰ 1852

SIXTH GREAT CONFLAGRATION IN SAN FRANCISCO, JUNE 22, 1851. (Charles Kimball, Noisy Carrier's Publishing Hall.) This illustration of the last of the great fires shows a view of the business district from Russian Hill and the size of the fire. (Courtesy of the California Historical Society.)

MERCHANT'S EXCHANGE, 1852 LITHOGRAPH. (Cook and LeCount.) The Merchant's Exchange Building in this 1852 lithograph was one of several early locations and proprietors. The exchange provided a place where business people could meet and acquire information on the arrival and departure of ships. (Courtesy of the California Historical Society.)

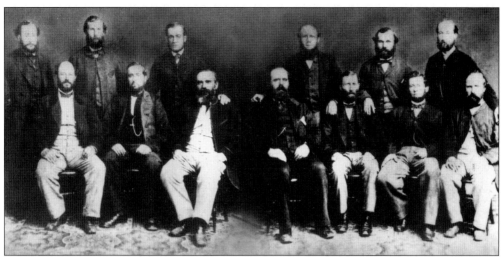

THE SAN FRANCISCO BAR PILOTS, 1852. Pictured here, from left to right, are (first row) William Lytton, William Shelly, Robert Leitch, William Rodgers, William Griffin, James Daly, and James Urie; (second tow) John Delevan, Edwin Jenkins, Samuel Nathan, William Jolliffe, M. McDonald, and John Ingram. (Courtesy of the San Francisco Bar Pilots Association.)

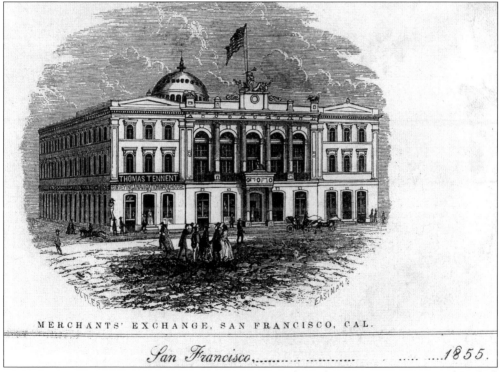

MERCHANT'S EXCHANGE ON BATTERY STREET, 1855. (Wood engraving. Eastman and Butler.) In 1855, the exchange was operated by Sweeney and Baugh, who also had a wharf at the foot of Dupont (Grant) Street. From this wharf, their men rowed out to meet the ships waiting to enter the bay and brought back the ship's name and cargo. In 1853, the first electric telegraph line on the West Coast was installed to facilitate this service. (Courtesy of the California Historical Society.)

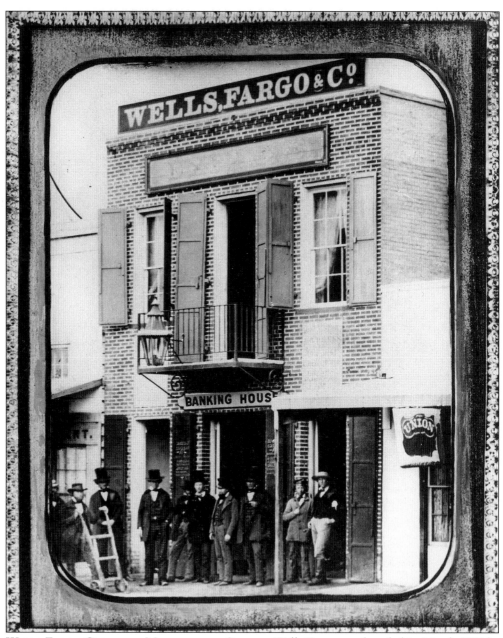

WELLS FARGO OFFICE ON MONTGOMERY STREET. Wells Fargo was founded in March 1852 by two eastern businessmen named Henry Wells and William G. Fargo. They had already established an express service that operated from the East Coast to Chicago and applied that experience to serving the mining camps of the west. Wells, Fargo, and Company headquarters were on Montgomery Street but opened offices in the mining communities of the Mother Lode where miners could bring their gold to be accurately weighed and exchanged. Wells Fargo also served as an express mail service and was known for serving areas where the postal service would not go. They were not the first express and banking business in San Francisco, but they won confidence as the best for their reliable service and trustworthy employees. (Courtesy of the San Francisco History Center, San Francisco Public Library.)

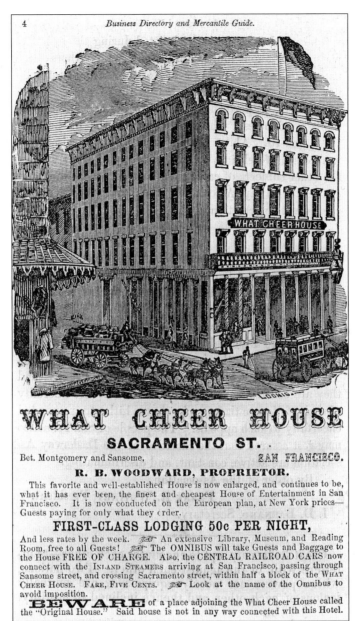

WHAT CHEER HOUSE

SACRAMENTO ST.

Bet. Montgomery and Sansome, SAN FRANCISCO.

R. B. WOODWARD, PROPRIETOR.

This favorite and well-established House is now enlarged. and continues to be, what it has ever been, the finest and cheapest House of Entertainment in San Francisco. It is now conducted on the European plan, at New York prices—Guests paying for only what they order.

FIRST-CLASS LODGING 50c PER NIGHT,

And less rates by the week. ☞ An extensive Library, Museum, and Reading Room, free to all Guests! ☞ The OMNIBUS will take Guests and Baggage to the House FREE OF CHARGE. Also, the CENTRAL RAILROAD CARS now connect with the INLAND STEAMERS arriving at San Francisco, passing through Sansome street, and crossing Sacramento street, within half a block of the WHAT CHEER HOUSE. FARE, FIVE CENTS. ☞ Look at the name of the Omnibus to avoid imposition.

BEWARE of a place adjoining the What Cheer House called the "Original House." Said house is not in any way connected with this Hotel.

WHAT CHEER HOUSE, 1852. On July 4, 1852, Robert Blum Woodward opened a hotel on Sacramento Street between Sansome and Montgomery called the What Cheer House. What Cheer House served men only and did not permit liquor. Woodward wanted to offer something to his guests other than the favored local entertainments of drinking, prostitution, and gambling. He opened a free museum and library that was considered, at the time, the best in the state. In 1866, he opened an amusement park called Woodward's Gardens in the Mission District. Most of his museum and library then became absorbed into that establishment. Woodward kept What Cheer House until the 1870s. He died in 1879 and the gardens fell on hard times. In the early 1890s, the contents of the gardens were auctioned off, and most of its library was purchased by Adolph Sutro. Over 100 years later, books used at What Cheer House and Woodward's Garden are still in use at the Sutro Library. (Courtesy of the California Historical Society.)

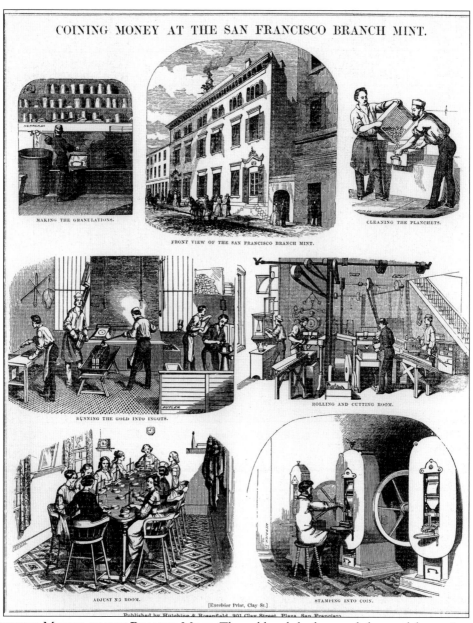

COINING MONEY AT THE SAN FRANCISCO BRANCH MINT.

MAKING THE GRANULATIONS.

FRONT VIEW OF THE SAN FRANCISCO BRANCH MINT.

CLEANING THE PLANCHETS.

RUNNING THE GOLD INTO INGOTS.

ROLLING AND CUTTING ROOM.

ADJUSTING ROOM.

[Excelsior Print, Clay St.]

STAMPING INTO COIN.

Published by Hutchings & Rosenfield, 201 Clay Street, Plaza, San Francisco.

COINING MONEY AT THE BRANCH MINT. The gold rush had created the need for a mint. In 1852, Congress gave the authorization for a U.S. mint to be established in San Francisco. The government bought a small building on Commercial Street that had been a private assaying office and converted it. The mint opened in 1854 and remained in operation until 1874, when the magnificent mint at Fifth and Mission Streets opened. The first mint was then torn down and a subtreasury building replaced it. In 1877, the subtreasury opened to serve as a branch of the treasury. Transactions between the government and individuals were processed there. The building remained in use until 1906, when it sustained heavy damage in the earthquake and fire. The top three floors were lost but the two lower floors were not. The building was sold in 1918 and is now owned by the Bank of Canton. The two bottom floors of the subtreasury building are now part of the Pacific Heritage Museum. (Courtesy of the California Historical Society.)

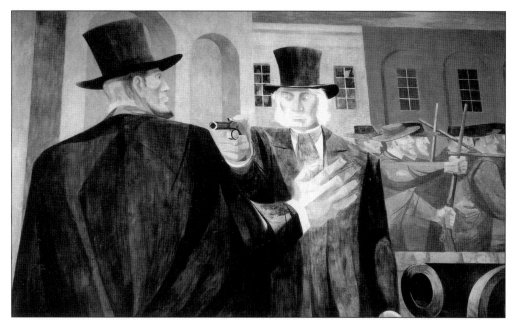

VIGILANTE DAYS. (Anton Refregier. Case-in-tempera. Rincon Annex, San Francisco 1946–1948.) The vigilantes first formed in 1851 in response to rampant crime, and gathered again in 1856 after the murder of a newspaper publisher by a corrupt city supervisor named James Casey. They took custody of Casey and Charles Cora, who was accused of shooting a federal marshal named William R. Richardson. (Christine Miller photograph, 2005.)

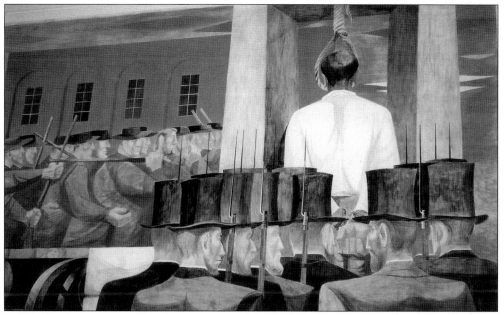

CASEY AND CORA. (Anton Refregier. Case-in-tempera. Rincon Annex, San Francisco 1946–1948.) The vigilantes headquartered in a warehouse on Sacramento Street called Fort Gunnybags, where Casey and Cora were tried and found guilty. They were hanged on May 22, 1856. The vigilantes continued their actions until August, hanging two more men and deporting others. (Christine Miller photograph.)

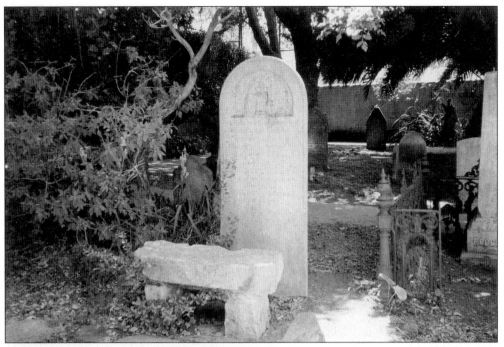

GRAVE OF CHARLES AND BELLE CORA. Three of the victims of the 1856 vigilantes are buried in the Mission Dolores cemetery. Pictured here is the grave of Charles Cora and his wife, Belle, who was a prominent madam in the 1850s. (Christine Miller photograph, 2001.)

N. GRAY AND COMPANY Founded in 1850, N. Gray and Company's advertising is often visible in early photographs of the Financial District. This badly damaged tombstone from 1852 in the Mission Dolores cemetery still has the "N. Gray, San Francisco" undertakers mark on the lower right side. (Christine Miller photograph.)

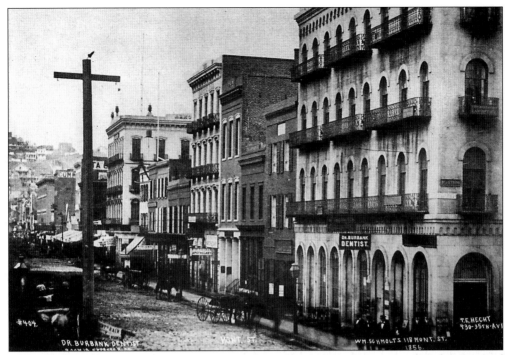

MONTGOMERY STREET, 1856. This photograph was taken at the corner of California and Montgomery Streets and shows the southern side of Montgomery Street. In the forefront is the Express Building, the first location of the Mechanics' Institute. (Courtesy of the San Francisco History Center, San Francisco Public Library.)

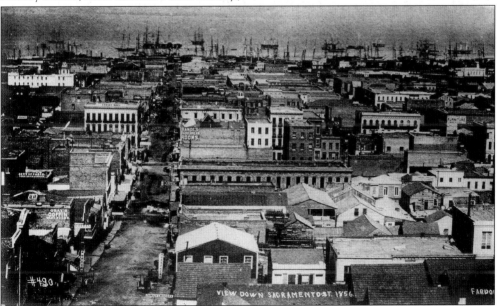

VIEW DOWN SACRAMENTO STREET, 1856. Taken from Dupont Street (Grant Avenue), this view shows the Financial District in 1856. San Francisco's population by this time had reached 30,000. The buildings were somewhat taller and more substantial. (T. E. Hecht photograph; courtesy San Francisco History Center, San Francisco Public Library.)

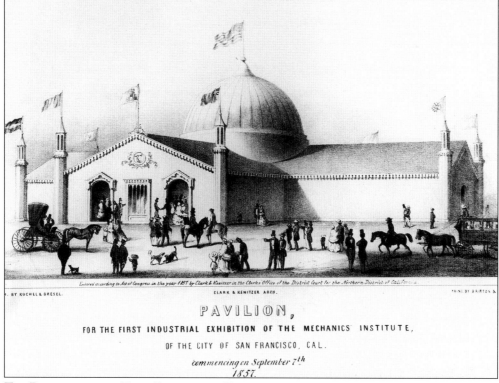

THE PAVILION OF THE FIRST INDUSTRIAL EXHIBITION OF THE MECHANICS' INSTITUTE, 1857. (Britton and Rey.) In 1855, the Mechanics' Institute was incorporated. Its goals were to provide a reading room and library, to provide technical education, sponsor lectures, and promote local industry. Between 1857 and 1899, the Mechanics' Institute also sponsored 31 industrial fairs. (Courtesy of the California Historical Society.)

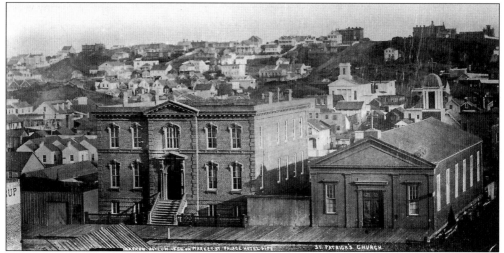

ST. PATRICK'S CHURCH. This photograph shows old St. Patrick's Church and the Orphan Asylum on Market Street and New Montgomery. This area would later become the site of the Palace Hotel. St. Patrick's was founded in 1851 to serve the Irish community. Today St. Patrick's is located at 756 Mission Street. (Courtesy of San Francisco History Center, San Francisco Public Library.)

Three

THE SILVER LEGACY

The development of the Financial District between 1860 and 1880 was dominated by two powerful forces, the largest silver strike in history and the transcontinental railroad. In 1859, silver was discovered in the mountains of Nevada and the subsequent events that played out there generated tremendous wealth for San Francisco. The mines were commonly known as the "Comstock Lode" and were located in the area around Virginia City, Nevada. The leading businessman of the silver era was a dynamic individual named William Chapman Ralston, and at the center of all business was his bank, the Bank of California. The bank kept a monopoly on the mines for many years but was eventually outmaneuvered by the "Silver Kings"—James G. Fair, John Mackay, James C. Flood, and William O'Brien.

The legacy of the Comstock Lode was lasting, but it was the construction of the western half of the transcontinental railroad by the Central Pacific Railroad that brought permanent changes. The money to build the railroad had come from four Sacramento shopkeepers named Collis P. Huntington, Charles Crocker, Mark Hopkins, and Leland Stanford. They were also known as "the Big Four."

Businesses established in the Financial District during this period included Townsend, Townsend, and Crew LLP (1860), Gump's (1861), Southport Land and Commercial Company (1861), Fireman's Fund Insurance Company (1863), the law firm of Orrick Herrington and Sutcliffe (1863), Heald College (1863), the Union Bank of California (1864), Jack's Restaurant, now Jeanty at Jack's (1864), the *San Francisco Chronicle* (1865), the *Examiner* (1865), Guittard Chocolate (1868), Sam's Grill (1868), the law firm of Pillsbury Winthrop Shaw Pittman (1874), the law firm of Chickering and Gregory (1875), and the Palace Hotel (1875).

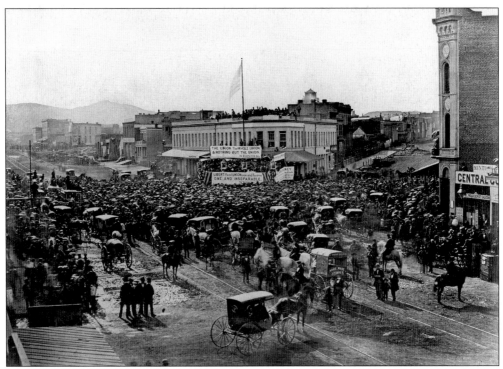

PRO-UNION RALLY, 1861. This pro-union rally took place at the intersection of Post, Montgomery, and Market Streets on May 11, 1861. At the time, there were fears that Southern sympathizers might take actions that would bind California to the Confederacy. In response, civic leaders planned a rally to demonstrate San Francisco's loyalty to the Union. (C. E. Watkins photograph; courtesy of the California Historical Society.)

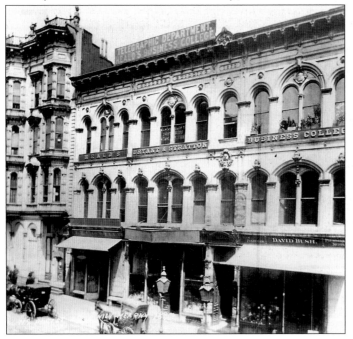

HEALD COLLEGE, 24 POST STREET. On August 8, 1863, Edward Payson Heald founded Heald College, the first business school in the western half of the United States. In the early days, the students used pens made out of quills to practice their penmanship. In 1879, the typewriter and shorthand were introduced. That was also the first year that women were able to enroll. Pictured here is 24 Post Street *c.* 1880. (Courtesy of the Marilyn Blaisdell collection.)

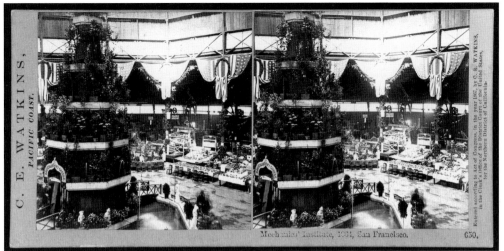

THE TWO-TON CALIFORNIA CHEESE. This 1864 stereoscopic view by C. E. Watkins comes from the Industrial Exhibition presented by the Mechanics' Institute. At the center is a special exhibit designed to raise funds for the U.S. Sanitary Commission, an organization that provided relief during the Civil War. This two-ton display of California cheese weighed close to 4,000 pounds and was built on five tiers. Entering the exhibit required an extra charge that went to the Sanitary Commission. (Courtesy of the Mechanics' Institute Library.)

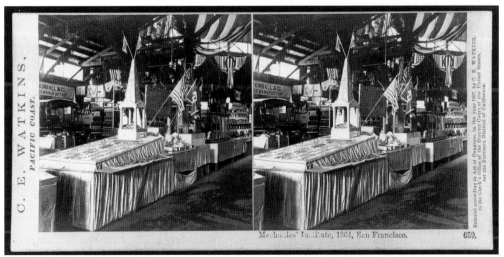

GHIRARDELLI CHOCOLATE EXHIBIT. In 1852, the Ghirardelli Chocolate Company was founded by Domingo Ghirardelli at the corner of Washington and Kearny. In 1857, the company began exhibiting their products at the Mechanics' Institute's exhibitions. At the 1864 exhibition pictured in this stereoscopic view by C. E. Watkins, Ghirardelli was awarded a gold medal for his chocolate exhibit. (Courtesy of the Mechanics' Institute Library.)

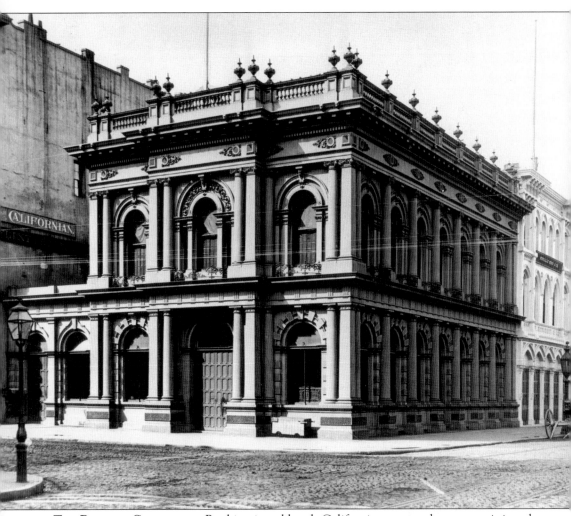

THE BANK OF CALIFORNIA. Banking in gold rush California was not the same as it is today. The limitations of the California state constitution were cumbersome and an informal style of banking was practiced in order to keep business going. William Chapman Ralston changed that by forming the first incorporated commercial bank in the state. The Bank of California opened on July 5, 1864, with prominent Sacramento banker Darius Ogden Mills as president and Ralston as cashier. Other banks came afterwards and by 1873 the state Supreme Court upheld that commercial banks were not unconstitutional. In 1868, Ralston moved the bank into its new building, pictured above, at the corner of California and Sansome Streets. The bank has been in business at that location ever since. The Bank of California also set up agencies in Virginia City and Gold Hill, Nevada. The bank's agent there, William Sharon, played a substantial role in the development of the mines of the Comstock. They no longer operates branches there, but their old bank in Virginia City lives on as a tourist attraction. The Bank of California was a powerful force in the economic development of the western United States and early international commerce. Today a small museum inside of 400 California Street illustrates the story of the bank that built the West. (Courtesy of the Union Bank of California.)

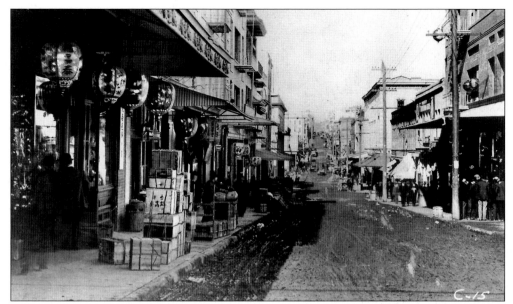

DUPONT STREET (NOW GRANT AVENUE), 1865. Chinese immigrants began arriving in San Francisco in 1848 and their numbers increased considerably during the construction of the transcontinental railroad in the 1860s. Early Chinatown bordered on Portsmouth Square but expanded to about a dozen blocks as the Chinese population grew. This photograph looks north from an unidentified corner on Dupont Street. (Courtesy of the San Francisco History Center, San Francisco Public Library.)

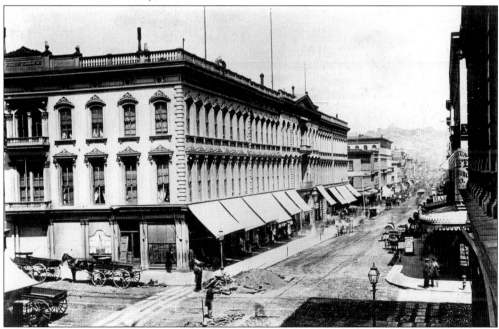

RUSS HOUSE, WEST SIDE OF MONTGOMERY. This photograph shows Montgomery Street looking north. The building in the center is the Russ House, between Bush and Pine Streets in 1865. The Russ Building would later be built on this site. (T. E. Hecht photograph; courtesy of the California Historical Society.)

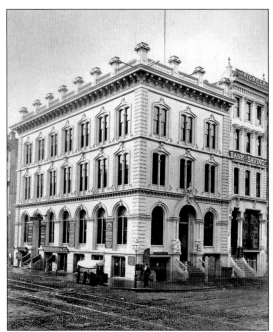

FIREMAN'S FUND BUILDING. Fireman's Fund Insurance Company, established in 1863, was named for an early arrangement whereby 10 percent of the company's profits went to the San Francisco Fire Department Charitable Fund. In 1867, Fireman's Fund built this three-story building on the southwest corner of Sansome and California Streets. The chimneys seen along the roof connected to coal-burning fireplaces. (Courtesy of Fireman's Fund Insurance Company.)

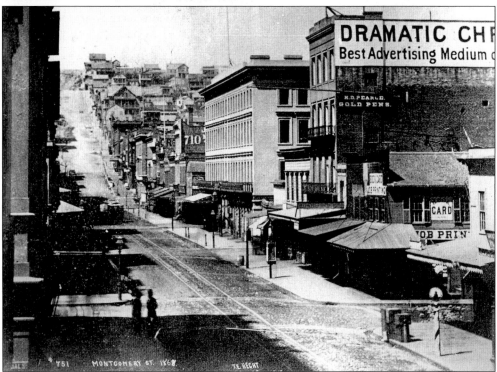

MONTGOMERY STREET, 1868. This view of the eastern side of Montgomery looks north from the corner of Montgomery and Commercial Streets. The advertisement on the left is for the *Daily Dramatic Chronicle*, now the *San Francisco Chronicle*. Next to it is the Montgomery Block, which is now the site of the Transamerica Pyramid. (T. E. Hecht photograph; courtesy of the San Francisco History Center, San Francisco Public Library.)

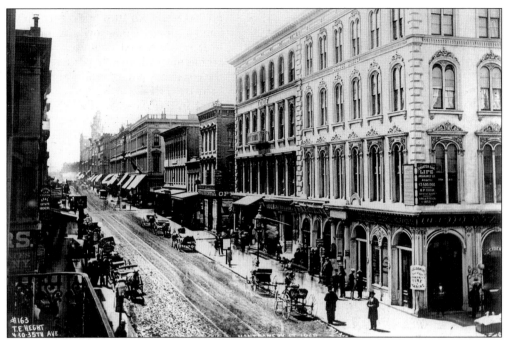

MONTGOMERY STREET, 1868. This view of the west side of Montgomery Street looks towards Market from the corner of Montgomery and California Streets. (T. E. Hecht photograph; courtesy of the San Francisco History Center, San Francisco Public Library.)

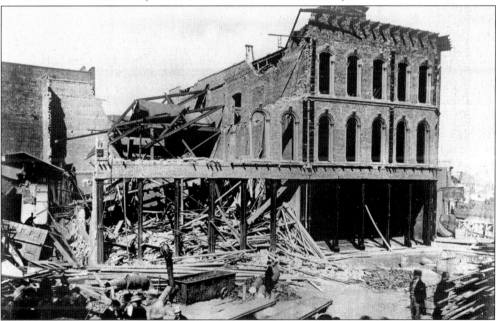

THE 1868 EARTHQUAKE. On October 19, 1868, a moderate earthquake centered on the Hayward Fault occurred and caused significant damage in the area east of Montgomery Street. This area had been created by filling in the shoreline with dirt and other materials in order to create room to build. This photograph shows damage at the northwest corner of Bush and Market Streets. (Courtesy of the San Francisco History Center, San Francisco Public Library.)

ADOLPH SUTRO (1830–1898). The Sutro name has been in the Financial District since the gold rush. The most prominent member of the Sutro family in San Francisco was Adolph Sutro, who arrived from Germany in 1850. He began as a tobacco merchant then joined the rush to Nevada in 1860. While there he constructed a large drainage tunnel for the Comstock mines and fought the monopolistic practices of the Bank of California. When Sutro returned to San Francisco in 1880, he purchased the land surrounding the Cliff House and transformed it into a recreational area for the working people of the city. He also continued to fight monopolies, most notably the Southern Pacific Railroad. In 1894, he was elected mayor of San Francisco. Adolph's cousins Gustav and Charles were founders of the prominent and long-lived stockbrokerage of Sutro and Company. Alfred and Oscar Sutro, cofounders of the law firm of Pillsbury, Madison, and Sutro (now Pillsbury Winthrop Shaw Pittman), were sons of Emil Sutro, also of Sutro and Company (Courtesy of the California Historical Society.)

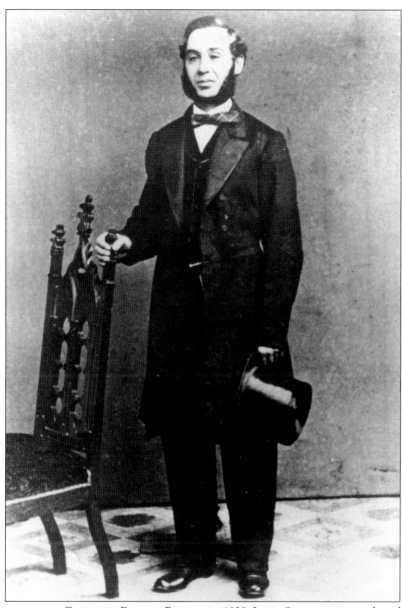

LEVI STRAUSS AND COMPANY Born in Bavaria in 1829, Levis Strauss emigrated to the United States in 1847 with his family. He learned the dry goods business in New York while working at the wholesale establishment owned by his older brothers. In 1853, he came to San Francisco and opened a wholesale warehouse on Sacramento Street, where he imported dry goods from his brothers' establishment in New York. The company later relocated to Battery Street. Strauss insisted that his employees call him "Levi." In 1871, a Nevada tailor named Jacob Davis made an innovation in work pants by using rivets to make the pants stronger. Davis asked Strauss, from whom he bought his cloth, to take out the patent with him because he lacked the funds for the $68 application. On May 20, 1873, they obtained the patent for riveted denim "waist overalls," now called jeans. Today blue jeans are the most popular apparel item in the world. Levi Strauss was also a considerable philanthropist and an active member of the Jewish community. (Courtesy of the San Francisco History Center, San Francisco Public Library.)

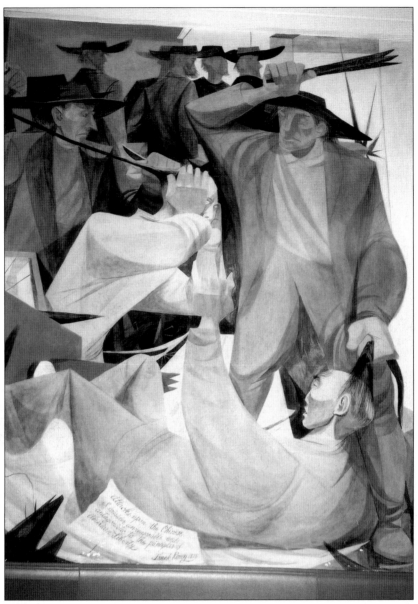

BEATING THE CHINESE. (Anton Refregier. Case-in-tempera. Rincon Annex, San Francisco 1946–1948.) Construction of the Central Pacific Railroad began in 1863, but progress was slow. In 1865, Chinese immigrant laborers were hired. They worked under grueling conditions for 12 hours a day, six days a week laying tracks for the railroad through difficult, mountainous terrain. Initially they were welcomed, but as their numbers grew they were subject to racism, attacks, and discriminatory laws. In the 1870s, an economic depression settled on San Francisco and unemployed white laborers saw the Chinese as the problem. In 1877, Denis Kearny and the Workingman's party pushed anti-Chinese sentiment further with riots and their slogan, "The Chinese Must Go!" In 1882, Congress passed the Chinese Exclusion Act, which stated that no Chinese immigrants would be allowed into America except for immediate relatives of Chinese who were already residents. The legislation stayed in effect until 1943. (Christine Miller photograph.)

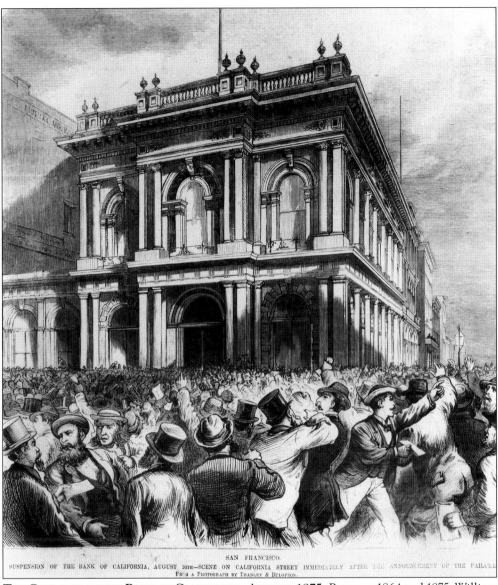

SAN FRANCISCO.

SUSPENSION OF THE BANK OF CALIFORNIA, AUGUST 26TH—SCENE ON CALIFORNIA STREET IMMEDIATELY AFTER THE ANNOUNCEMENT OF THE FAILURE

FROM A PHOTOGRAPH BY BRADLEY & RULOFSON.

THE COLLAPSE OF THE BANK OF CALIFORNIA, AUGUST 1875. Between 1864 and 1875, William Chapman Ralston had transformed the Financial District and built the Bank of California into the most powerful bank on the West Coast. By 1875, however, the bank had lost its monopoly on the Nevada mines to four men who came to be called the "Silver Kings" when their mine struck the richest vein of the Comstock. Ralston had overextended himself and the bank with too many unprofitable investments and stock speculations. By the time he began to sell off his assets, it was already too late—a run on the Bank of California began on August 26, 1875. Crowds filled the streets outside and police had to maintain order. The bank ultimately could not meet the demand and closed its doors. Ralston resigned the next day and died shortly afterwards. Darius Ogden Mills, William Sharon, and the bank's directors reorganized and reopened the bank on October 2, 1875. It has continued ever since. (Courtesy of the California Historical Society.)

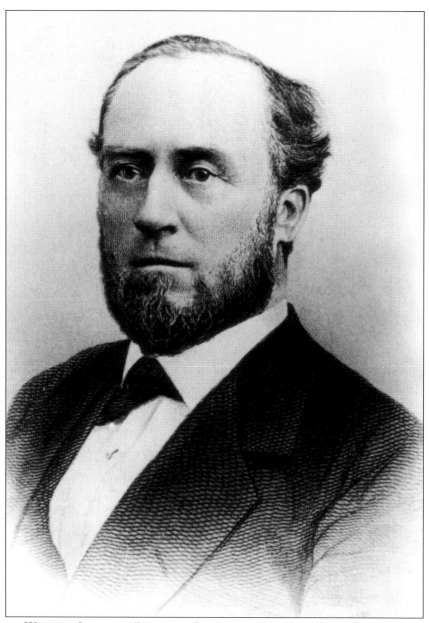

DEATH OF WILLIAM CHAPMAN RALSTON. On August 27, 1875, William Chapman Ralston was asked to resign from the Bank of California and turn over all his assets to William Sharon. He did so and left the bank to take a swim in North Beach. Ralston later died of a stroke or a heart attack while in the water. His funeral brought an immense outpouring of grief. The community saw him as a man who had given his all to San Francisco, a city in which he had nothing but faith. His achievements were numerous and his charity well-known. William Sharon took control of Ralston's considerable estate and quickly settled with Ralston's widow and creditors—at what appeared to be his own gain. There is a monument to Ralston in the marina but not in the Financial District. His legacy lives on with the two most prominent institutions he founded, the Bank of California and the Palace Hotel. Events in Ralston's life were dramatized in episodes of the old NBC television series *Death Valley Days*. (Courtesy of the Union Bank of California.)

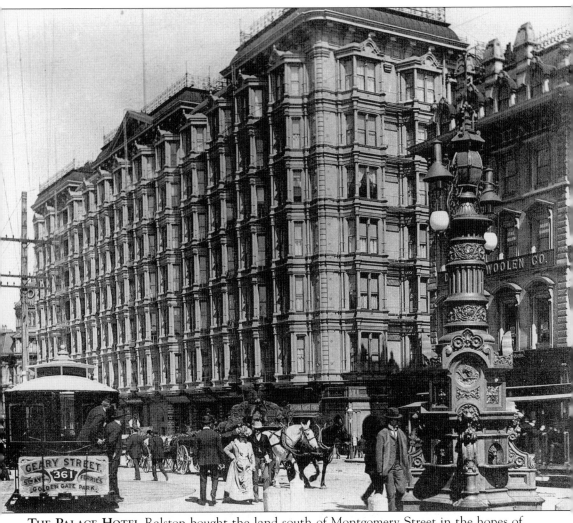

THE PALACE HOTEL Ralston bought the land south of Montgomery Street in the hopes of extending it farther south, but "New Montgomery" ultimately only got as far south as Howard Street. He believed the area should be developed, but it wasn't until 1872 that he devised what to do with it. He set out to construct the largest building on the West Coast, the Palace Hotel. It was a massive construction project that took two years to build and cost $5 million. Ralston was known for his extravagance and the Palace Hotel lived up to that reputation. No expense was spared in the construction or the opulent furnishings. The Palace Hotel was to be symbolic of the new, more sophisticated city San Francisco had become since the gold rush. It was seven stories high and had 800 rooms. The Palace opened in October 2, 1875, the same day that the Bank of California reopened. Also in this photograph is Lotta's Fountain, a gift given to the city from entertainer Lotta Crabtee that same year. (Courtesy of the San Francisco History Center, San Francisco Public Library.)

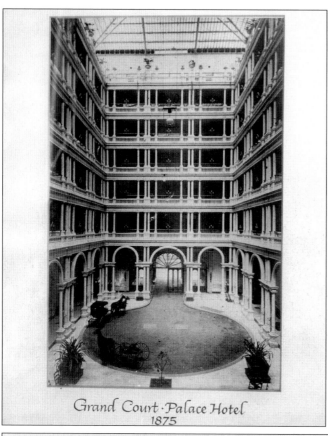

GRAND COURT OF THE PALACE HOTEL, 1875. The Palace Hotel had three interior courts. The central one, pictured here, opened from New Montgomery Street and allowed carriages to enter the hotel and drop their passengers off. From there, elevators took them to their rooms. (Courtesy of the Palace Hotel.)

Grand Court · Palace Hotel 1875

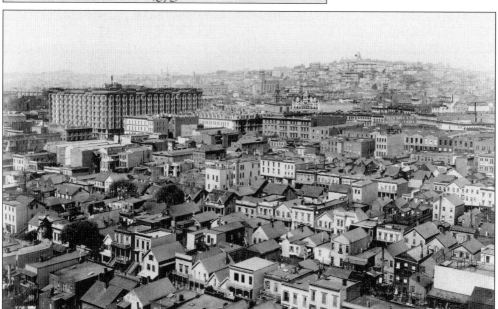

BIRD'S-EYE VIEW OF SAN FRANCISCO, TOWARDS PALACE HOTEL AND NOB HILL. This photograph, taken around 1885, illustrates the tremendous size of the Palace Hotel in proportion to the surrounding South of Market community. (Courtesy of the California Historical Society.)

WILLIAM SHARON.
Pictured here is
William Sharon
(1821–1885), who
was the agent for the
Bank of California in
Nevada during the era
of the Comstock Lode.
In 1875, he became
a senator in Nevada
with little distinction.
Sharon is notorious
for many reasons,
including his rise to
power after William
Ralston's death and
his sensational divorce
case in the 1880s.
(Courtesy of the San
Francisco History
Center, San Francisco
Public Library.)

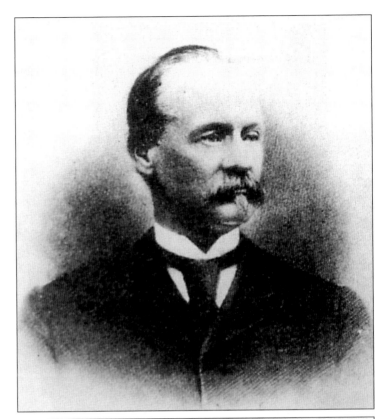

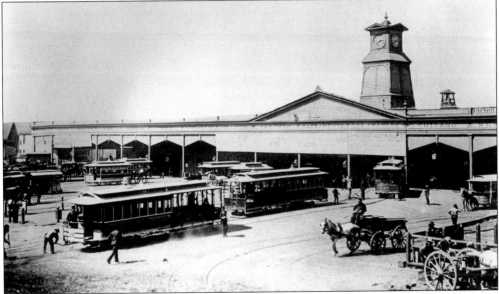

FERRY HOUSE. On September 4, 1875, the Ferry House opened at the foot of Market Street. The port commissioners had removed the Clay Street and Commercial Street wharves in order to build an appropriate structure to meet transportation demands. This building was replaced in the 1890s with the Ferry Building that is seen today. (Courtesy of the San Francisco History Center, San Francisco Public Library.)

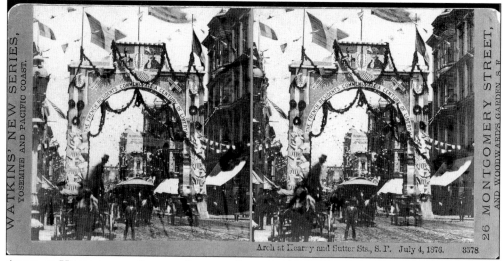

ARCH AT KEARNY AND SUTTER STREETS, JULY 4, 1876. This elaborate arch erected for the centennial Fourth of July celebration bears the words, "The French Residents Commemorate a Century of Liberty." Today the French community is visible in the Financial District on Bastille Day, when Belden Alley is closed off for a boisterous celebration. The Mechanics' Institute also continues a tradition of observing Bastille Day. (Courtesy of the California Historical Society.)

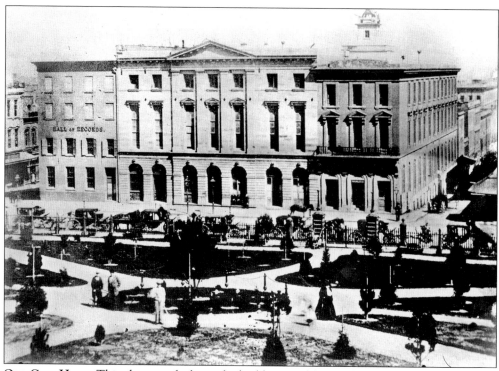

OLD CITY HALL. This photograph shows the building used for city hall between 1878 and 1895. It was formerly the Jenny Lind Theater. It was located on Kearny between Clay and Sacramento Streets. Portsmouth Square is in the forefront. (Courtesy of the San Francisco History Center, San Francisco Public Library.)

Four

THE GILDED AGE

Between 1880 and 1906, the Financial District underwent changes that began to shape the neighborhood seen today. Its development was also affected during this time by the neighborhoods around it, particularly Chinatown and the Barbary Coast. Telephone service, expanded transportation lines, and early skyscrapers were introduced to meet the growing demands of the business district. On the waterfront, sailors worked to unionize and change the abuses of the system under which they worked.

The most powerful corporation in the Financial District during this era was the Southern Pacific Railroad, which had merged with the Central Pacific Railroad in 1885. The resulting transportation monopoly controlled rail and shipping lines into San Francisco and determined freight rates. Their reach spread throughout California and they were often referred to as "the Octopus." One of the enduring legacies of the Southern Pacific resulted from the 1886 U.S. court case *Santa Clara County v. Southern Pacific Railroad,* which gave corporations constitutional rights.

Some of the notable businesses and institutions founded in the Financial District during this period include Morrison and Foerster LLP (1881), Matson Navigation (1882), the Hearst Corporation (1887), Schroeder's Restaurant (1893), Heller Ehrman (1896), Del Monte Foods (1898), and Gimbal's Fine Candies (1898). The Commonwealth Club, the oldest and largest public affairs forum in the nation, was founded in 1903. The Pacific Gas and Electric Company was established in 1905, but the smaller gas and electric companies from which it was formed date back to the gold rush era.

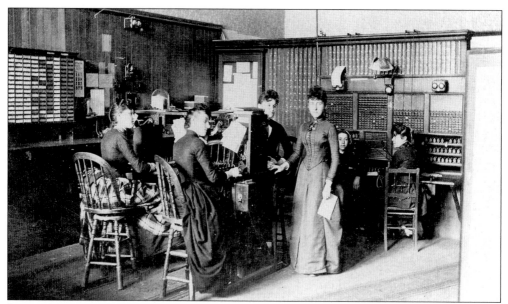

PACIFIC TELEPHONE AND TELEGRAPH OPERATORS. San Francisco was the first region in California to have telephone service. Telephones were first introduced in 1877 by the Gold and Stock Telegraph company, one of the companies that later became part of Pacific Telephone and Telegraph Company. This photograph of lady telephone operators was taken in 1880. (Courtesy of the California Historical Society.)

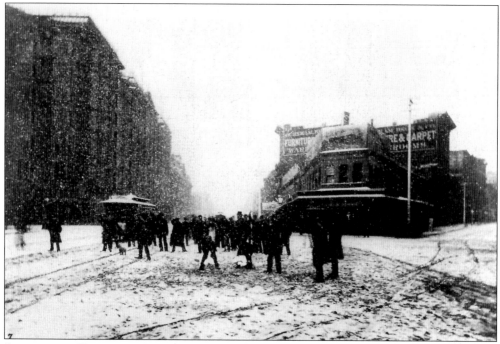

SNOW IN THE FINANCIAL DISTRICT. On February 5, 1887, San Francisco had a record snowfall of 3.7 inches. This photograph was taken at the intersection of Market and Post Streets. The Palace Hotel is in the background. (Courtesy of the Bancroft Library, University of California, Berkeley.)

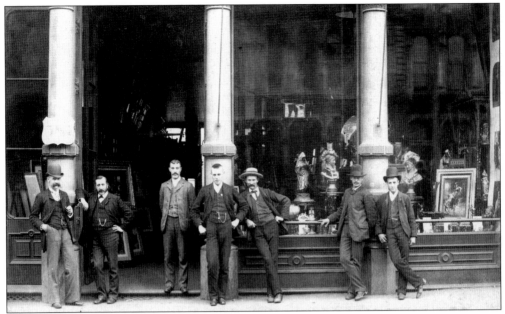

GUMP'S. The first Gump's opened in 1861 on Clay Street and became the preeminent provider of fine architectural and decorative ornamentation in San Francisco. Over time, "S. and G. Gump: Mirrors, Mouldings, and Paintings" evolved into a retail store known for its Oriental and European treasures. This 1880s photograph shows the front of their store at 581 Market Street. From 1876 to 1892, Gump's operated in this location. (Courtesy of Gump's.)

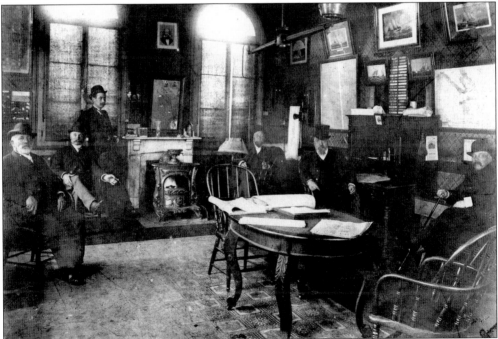

SAN FRANCISCO BAR PILOT OFFICE. This 1896 group photograph of the bar pilots was taken in their office at 506 Battery Street. Pictured, from left to right, are G. Scott, S. Castle, A. Swanson, T. Barber, and G. Kortz. (Courtesy of the San Francisco Bar Pilots Association.)

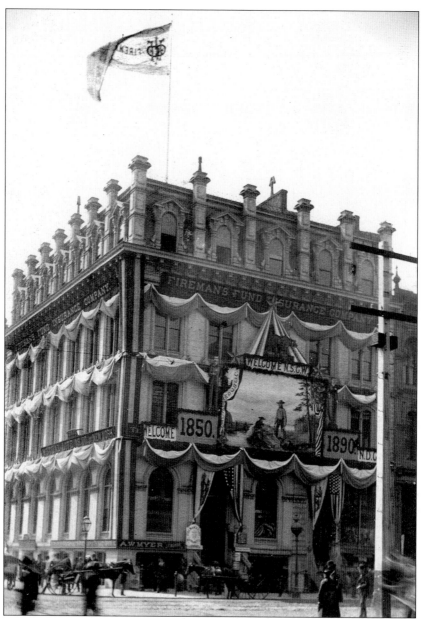

Fireman's Fund Building. In 1890, San Francisco hosted a celebration for the 40th anniversary of California's admission to the Union. The enormous celebration, headquartered at the Mechanics' Institute Pavilion, included parades, concerts, and other festivities. Many pioneers returned to San Francisco for the events, some of whom had not seen the city since they had first arrived in California during the gold rush. The city's streets, residences, and buildings were lavishly decorated with patriotic colors and images of the California grizzly bear. According to the *Examiner* newspaper on September 9, 1890, "It is estimated that at least a half a million patriotic emblems are displayed between the heavens and the pavements. To say the city is intoxicated is not a mere figure of speech—it is scarcely the truth." Fireman's Fund Insurance won a prize for their building's elaborate Admissions Day decorations at 401 California Street that welcomed the Native Sons of the Golden West to San Francisco. (Courtesy of Fireman's Fund Insurance Company.)

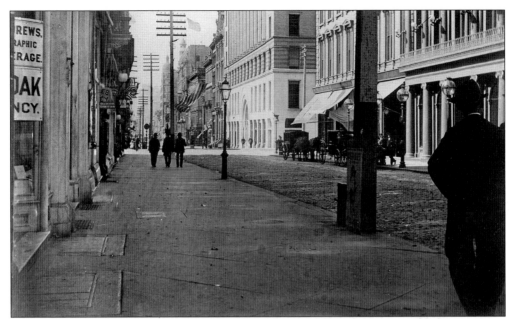

MONTGOMERY STREET AT BUSH. This photograph of Montgomery Street shows the development of this particular business corridor by the turn of the 20th century. Seen in the center of the photograph, the Mills Building at 220 Montgomery Street was built in 1892 by Darius Ogden Mills. The 10-story building was designed by the Chicago firm of Burnham and Root, and is the only building in this photograph still in existence. (Courtesy of the California Historical Society.)

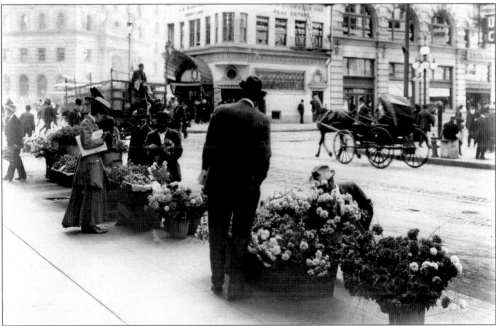

FLOWER STAND ON KEARNEY AT MARKET STREET. Turn of the 19th century flower stands were not unlike those seen in the Financial District today. The tradition of flower stands in the Financial District is said to have started in the 1870s. (Courtesy of the San Francisco History Center, San Francisco Public Library.)

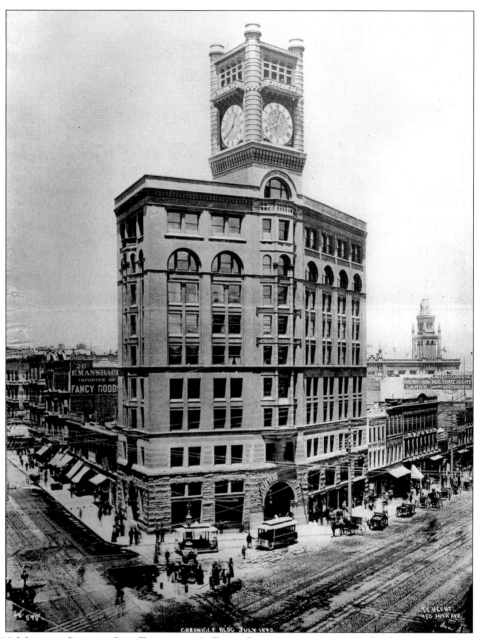

690 MARKET STREET, SAN FRANCISCO'S FIRST SKYSCRAPER. In 1889, the first iron and steel-frame skyscraper in San Francisco was constructed at the corner of Kearny and Market Streets. It was designed by the Chicago architectural firm of Burnham and Root, and built for the *San Francisco Chronicle*, which occupied the 10-story building for 34 years. At the time it was built, it was the tallest building in San Francisco. The later additions to the structure were made by architect Willis Polk. The Chronicle Building was one of the few that survived the 1906 earthquake and fire. In 1962, the building was remodeled and its brick exterior was covered by a thin metal veneer in order to modernize its appearance. In 2005, the removal of that veneer began as part of a restoration and renovation of the building. (T. E. Hecht photograph; courtesy of the San Francisco History Center, San Francisco Public Library.)

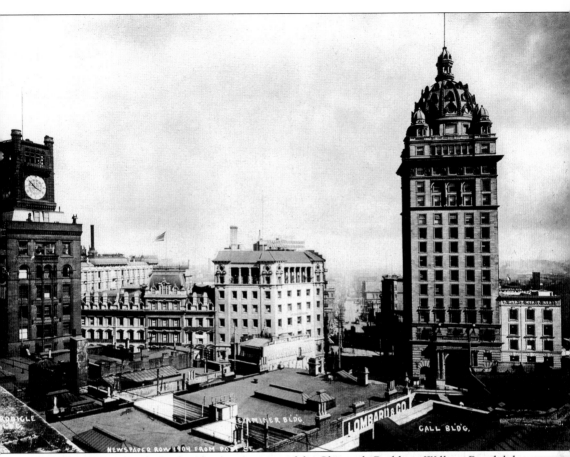

NEWSPAPER ROW. Not long after the construction of the Chronicle Building, William Randolph Hearst bought the property across the street and moved the *Examiner* to that site. In 1895, Claus Spreckels bought the *San Francisco Call* and moved that newspaper to a 19-story tower at 703 Market Street, across from the other two newspapers. The intersection of Market, Kearny, Third, and Geary Streets subsequently became known as "newspaper row." In this photograph, the Chronicle Building is on the left, the Examiner Building in the center, and the Call Building on the right. The original Examiner Building was destroyed in the earthquake and fire and replaced by the Hearst Building at 691-699 Market Street, where it stands today. (Courtesy of the San Francisco History Center, San Francisco Public Library.)

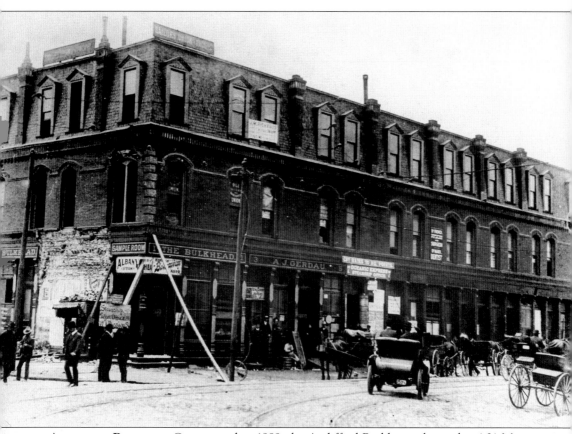

AUDIFFRED BUILDING. Constructed in 1889, the Audiffred Building is located at 1-21 Mission Street. Seen here are two of its early tenants, the Coast Seamen's Union and the Bulkhead Saloon. The Coast Seamen's Union, now known as the Sailor's Union of the Pacific, was the first sailor's union in history. During the 1901 waterfront strike, Andrew Furuseth of the Sailor's Union of the Pacific, marshaled the City Front Federation (the group of unions locked out from their jobs) from this building. The Audiffred Building was not damaged in the 1906 earthquake and the story of how the fires were staved off states that the firemen were given wine and whisky in exchange for rescuing the building. In the 1930s, Harry Bridges organized San Francisco's longshoremen from offices within the Audiffred Building. On July 5, 1934, two men were killed outside the building during the Longshoreman's Strike, an event still commemorated by local unions today. The Audiffred Building is a National Historic Landmark, and underwent an extensive restoration between 1982 and 1984. Today it is home to the restaurant Boulevard. (Courtesy of the San Francisco History Center, San Francisco Public Library.)

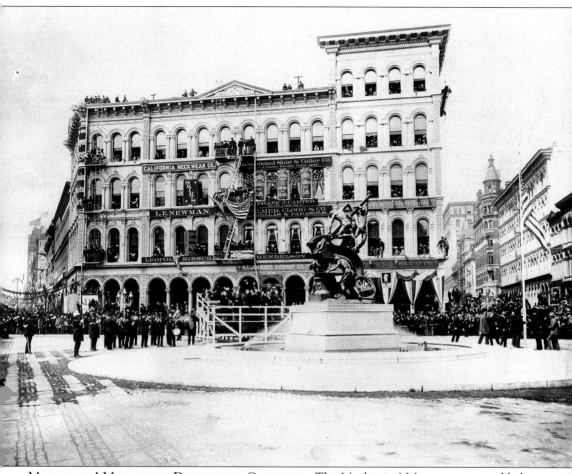

MECHANICS' MONUMENT DEDICATION CEREMONY. The Mechanics' Monument was added to the landscape of the Financial District on May 15, 1901, at the gore of Battery, Market, and Bush Streets. When it was new, the bronze monument was in the center of a grand, circular water fountain. The sculpture of a group of five semi-nude men attempting to punch a metal plate was created by Douglas Tilden. There was some initial controversy over the statue's design due to the nudity, but a petition was circulated on behalf of the sculptor's vision and the statue was approved. The architect of the granite base was Willis Polk. The Donahue Memorial Fountain was a gift to the city by James Mervyn Donahue, in memory of his father, Peter Donahue, founder of the city's first iron foundry, street railway, and gas company. (Courtesy of the California Historical Society.)

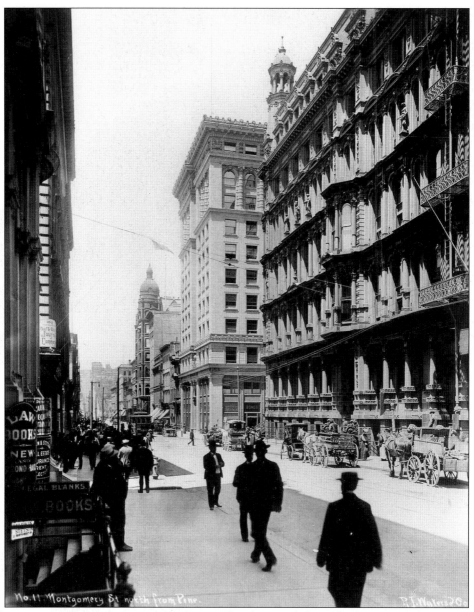

No. 11 Montgomery St. north from Pine. R. J. Waters & Co.

MONTGOMERY STREET NORTH FROM PINE. This photograph shows the intersection of Montgomery and California Streets at the turn of the twentieth century. At the very center of the photograph is the Kohl Building at 400 Montgomery Street. It the only building in this photograph that still exists. Alvinza Hayward, a Comstock millionaire associated with the Bank of California, had the building at 400 Montgomery Street constructed in 1901 by George W. Percy and Willis Polk. It later became known as the Kohl Building. An early example of fireproof design, the building survived the 1906 earthquake and fire. It is said that the building has an "H" shape due to superstition about initials. Alvinza Hayward's legacy in the Financial District is also connected to one of its oldest companies, the Southport Land and Commercial Company, established in 1863. (R. J. Waters and Company photograph; courtesy of the San Francisco History Center, San Francisco Public Library.)

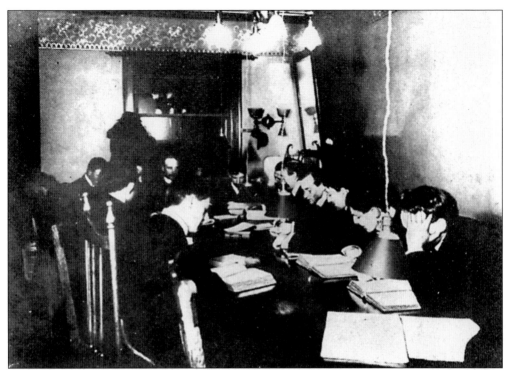

THE LAW STUDENTS. This 1903 photograph is the earliest known photograph of Golden Gate University law students. Golden Gate University began in 1881 as the YMCA Night School, the first evening school in the city. In 1901, the YMCA Evening School of Law was also established and became the first evening law school in northern California. (Courtesy of Golden Gate University.)

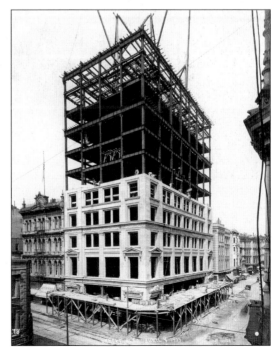

THE SHREVE BUILDING, 1905. The building shown here under construction at the corner of Post and Grant was named for its tenant, Shreve and Company (established 1852). In March 1906, the company moved to this building. The earthquake and firestorm occurred a month later. This building was the only one in eight square blocks to survive. After temporarily relocating to Oakland for two years, Shreve and Company returned to their restored building. (Courtesy of the San Francisco History Center, San Francisco Public Library.)

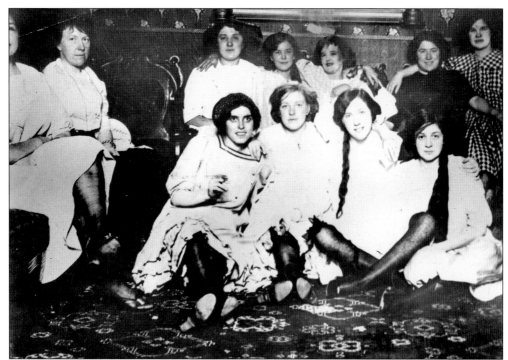

THE LADIES. The Barbary Coast began in the 1850s and eventually centered on Pacific Avenue and Broadway Street. Prostitution was the main industry of the area and the establishments of the Barbary Coast ranged in style and price. This 1890s photograph shows a group of unidentified Barbary Coast prostitutes. (Courtesy of the Marilyn Blaisdell collection.)

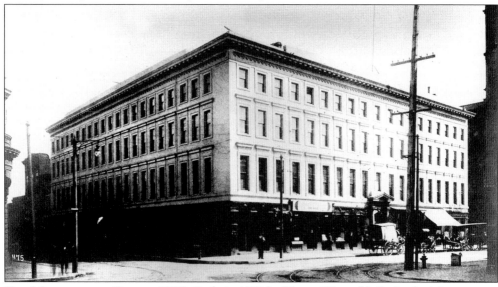

THE MONTGOMERY BLOCK, 1905. Built in 1853 by Henry Wager Halleck, the Montgomery Block housed many notable businesses, lawyers, and artists. Also known as "the Monkey Block," it survived the 1906 earthquake and fire but was torn down years later to make way for a parking lot. Today the Transamerica Pyramid stands on this site. (Courtesy of the San Francisco History Center, San Francisco Public Library.)

Five

THE EARTHQUAKE
AND FIRES

The most significant events in the history of San Francisco are undoubtedly the earthquake that occurred on April 18, 1906, and the fires that followed. Still considered America's worst urban disaster, its legacy effects the Financial District to this day. The official death was listed as 478, but that number is currently being revised to more accurately represent the loss of life. The Financial District was destroyed during the first day of the fires.

The magnitude 8.25 earthquake occurred at 5:12 a.m., and knocked out all transportation and telephone lines. Despite this, employees arrived for work that day. Their immediate concern became the firestorm and what could be saved or moved. The last working telegraph wire in the city was the private wire at the stockbrokerage Sutro and Company. The *Examiner* used Sutro's wire to send news of the earthquake to New York until it finally gave out and San Francisco lost its last connection to the outside world.

After the fire, many businesses found themselves reduced to only what their employees had been able to rescue. Bank vaults sealed by the fire required three weeks to cool or the contents would combust. One of the more famous stories is that of A. P. Giannini, who loaded up the assets of his Bank of Italy (now Bank of America) in two borrowed horse-drawn produce carts before the fire and drove them to his home in San Mateo. The bank's money arrived safely but retained the scent of oranges for some time afterward.

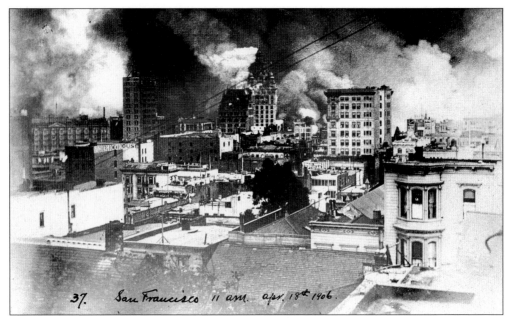

FINANCIAL DISTRICT IN FLAMES. This photograph of downtown San Francisco in flames was taken at 11:00 a.m. on April 18, 1906. The photograph is looking east towards the downtown area. At the center of the photograph is the Call Building at 703 Market Street and the Mutual Savings Bank Building at 704 Market Street, both of which survived the fire. (Courtesy of the San Francisco History Center, San Francisco Public Library.)

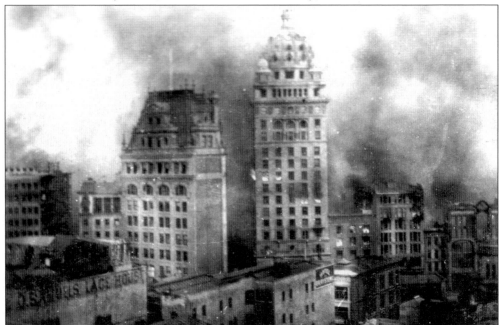

THE CALL BUILDING ON FIRE. Fire consumes the Call Building at 703 Market Street and the buildings around it as seen in this photograph taken by a PG&E employee. Across Market Street from the Call Building is the Mutual Savings Bank Building. (Courtesy of Pacific Gas and Electric Company.)

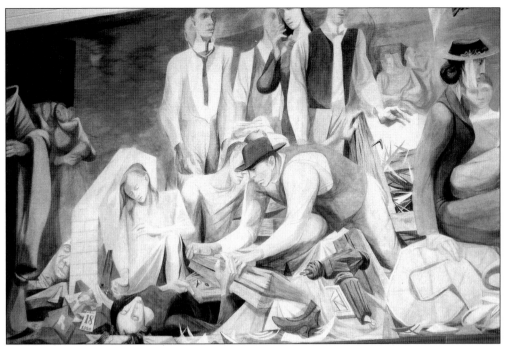

THE EARTHQUAKE AND FIRE OF 1906. (Anton Refregier. Case-in-tempera. Rincon Annex, San Francisco 1946–1948.) This portion of Anton Refregier's mural of the 1906 disaster shows the dazed, ghostly survivors of the earthquake and fire. At the center of the image a man is struggling to free the body of a woman from debris. (Christine Miller photograph.)

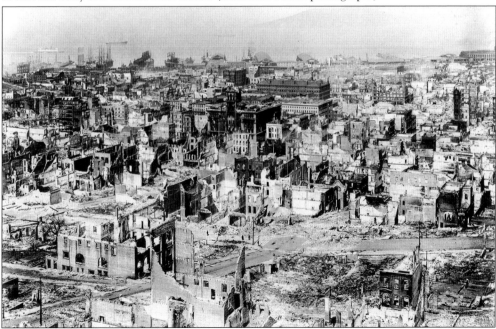

AFTER THE FIRE. The devastation to Chinatown, Portsmouth Square, and the Barbary Coast is evident in this view from Clay and Stockton Streets. At the center of the photograph is the old city hall building on Portsmouth Square. (Courtesy of the California Historical Society.)

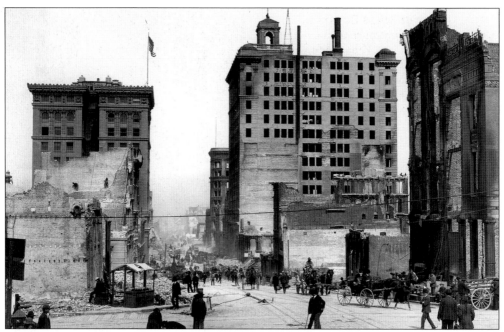

CALIFORNIA STREET AFTER THE FIRE. This photograph looks east, down California Street towards Market Street. The section of California Street seen in the photograph is the area between Montgomery and Kearny Streets. The Kohl Building is on the left with its flag waving. The Merchant's Exchange Building is on the right. (Courtesy of the California Historical Society.)

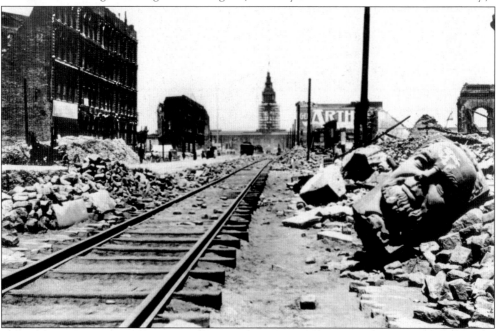

LOWER MARKET STREET AFTER THE FIRE. This view shows lower Market Street with the Ferry Building in the distance. The giant stone head was a remnant from the Lachman Brothers Building. Within a month, the streetcars on Market Street were running. (Courtesy of Pacific Gas and Electric Company.)

ENTRANCE TO THE MILLS BUILDING.
Pictured here is the entrance to one of the
survivors of the fire, the Mills Building at
220 Montgomery Street. Built in 1891, it
was the first entirely steel-frame building in
San Francisco. (Courtesy of the California
Historical Society.)

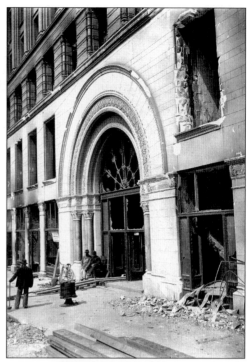

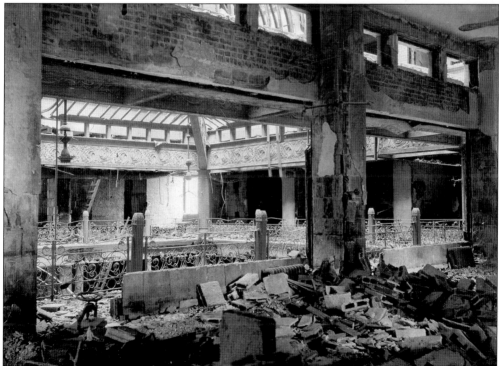

INTERIOR OF THE MILLS BUILDING. The burned out interior of the Mills Building at 220
Montgomery Street shows the damage of fires that reached above 2000 degrees Fahrenheit.
(Courtesy of the California Historical Society.)

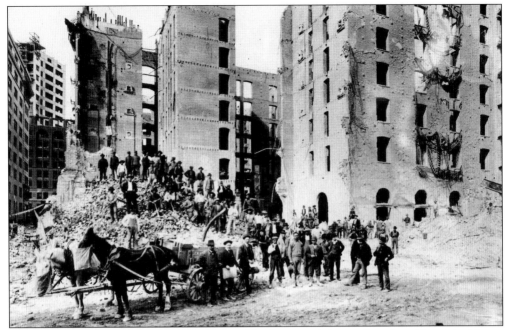

PALACE HOTEL AFTER THE FIRE. The Palace Hotel survived the earthquake without significant structural damage. Though employees kept the roof of the hotel hosed down to protect it from the encroaching fires, the hotel eventually was abandoned to the flames. Palace Hotel workers gathered for a group photograph amidst the ruins. (Courtesy of the Palace Hotel.)

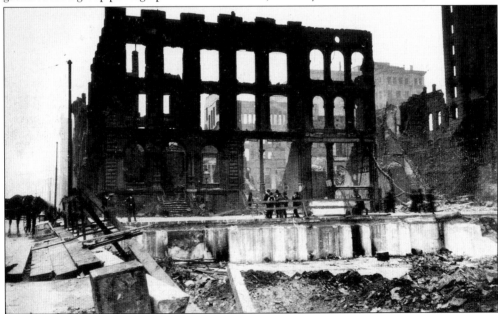

THE FIREMAN'S FUND BUILDING. Shown here is the Fireman's Fund Building at 401 California Street. Before the building caught fire, young Fireman's Fund employees worked furiously to rescue the company's records and valuables. As they worked, they would stop and put their hands up to the window to feel the heat and judge the closeness of the oncoming fire. (Courtesy of Fireman's Fund Insurance Company.)

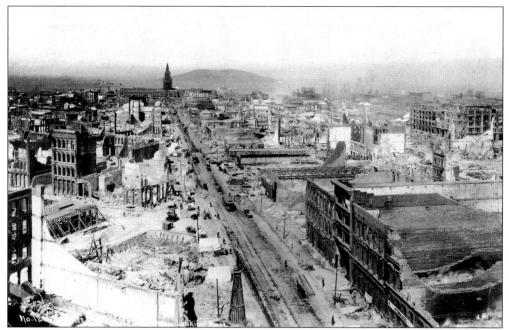

MARKET STREET AFTER THE EARTHQUAKE AND FIRE. This photograph of Market Street was taken from a building at the intersection of Market and Montgomery Streets. It shows the extent of the destruction to the north and south sides of Market Street. (Courtesy of the California Historical Society.)

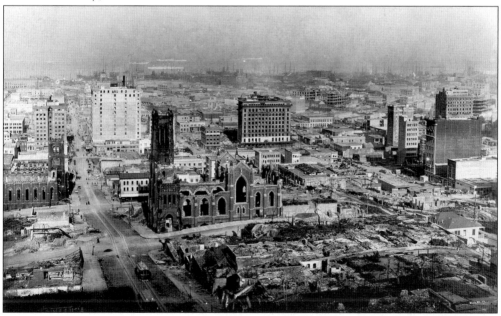

CALIFORNIA STREET FROM THE FAIRMONT HOTEL. The destruction of the Financial District and the South of Market area is evident in this photograph. At the center is the Mills Building at 220 Montgomery Street. On the left side of the photograph is California Street, where the Kohl Building and the Merchant's Exchange Building stood out as surviving structures. (Courtesy of the California Historical Society.)

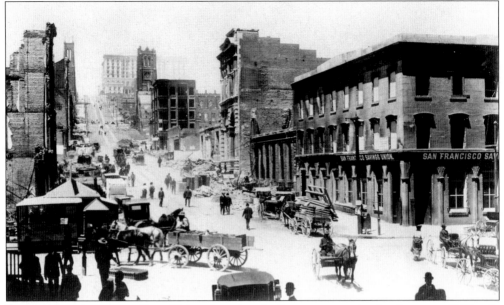

THIRTY DAYS AFTER THE FIRE. Thirty days after the fire, reconstruction has begun on California Street Hill, seen here from California and Montgomery Streets. Horse teams hauled away debris and delivered building materials. Thousands of horses were worked to death to rebuild the city. (Courtesy of the California Historical Society.)

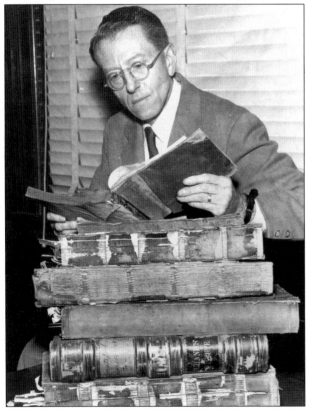

THE BOOKS. Mechanics' Institute librarian John Stump is pictured here with the stack of books that survived the earthquake and fire. The Mechanics' Institute lost their collection of 200,000 books and their building in the fire. A number of remarkable private and public libraries suffered the same fate and many priceless works were lost. (Courtesy of the Mechanics' Institute Library.)

Six

RECONSTRUCTION

San Franciscans set about the task of rebuilding the city at a rapid pace. Troubles during this difficult era of reconstruction included strikes, a plague outbreak, and six years of graft trials that implicated politicians and prominent businessmen. Yet, by 1909, San Francisco was considered to be mostly rebuilt. The Panama Pacific International Exhibition of 1915, held in the Marina District, was produced to showcase San Francisco's renewal.

Many businesses lost their offices and company records in the earthquake and fires of 1906. Most companies moved to Oakland or the Fillmore District while reconstruction of the Financial District took place. One company that lost everything in the fire and had to relocate during reconstruction was the law firm of Pillsbury Madison and Sutro (now Pillsbury Winthrop Shaw Pittman). The story of their firm's experience was recounted by John Sutro in 1977. "My father (Alfred Sutro) often told the story of how he and Mr. E. S. Pillsbury rented a horse and wagon and drove around San Francisco looking for office space. They finally located this space out on Pine and Webster, which became known as the "Little Mills Building" because so many other lawyers went out there. I've often heard my father tell the story of how he and Mr. Pillsbury went into the building. He had a sign that said "Law Offices of Pillsbury Madison and Sutro" and he leaned out the window and tacked it up while Mr. Pillsbury hung onto his feet."

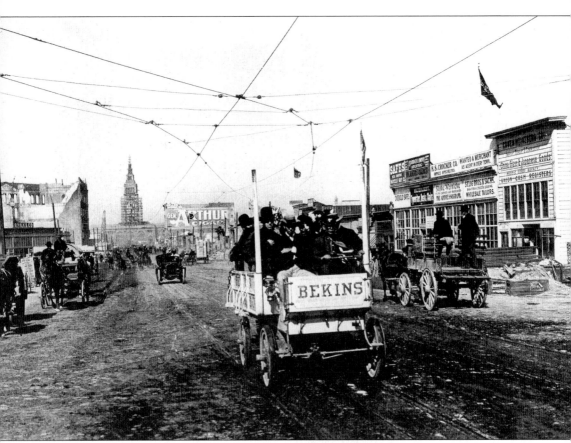

TRANSIT STRIKE, 1907. This photograph shows commuters traveling down Market Street during a conductor's strike in May 1907. According the *San Francisco Call* newspaper on May 5, 1907, "the scene in front of the ferry building brought back to recollection those witnessed there immediately after the fire a year ago. Instead of the few teams that had lined up at that time, there were hundreds of vehicles ready to carry newcomers to any part of the city. Every variety of vehicle was put into use. There were swell automobiles, four in hand traps, wagonettes, great trucks, express wagons, buggies, carriages and numerous antique concerns which had been dragged into service no one seems to know from where, all ready to carry the arrivals up Market Street as far as Fillmore at 25 cents a head. The supply of improvised buses more than met the demand." Business was so brisk and competitive among the drivers reported the *Call*. "Such a rumpus had never before been raised on the waterfront." (Courtesy of the San Francisco History Center, San Francisco Public Library.)

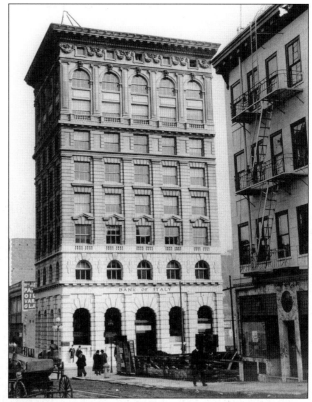

THE BANK OF ITALY. Between 1908 and 1921, this building was the Bank of Italy headquarters. The Bank of Italy became the Bank of America, the largest bank in the United States. The building is now a National Historic Landmark. (Courtesy of the San Francisco History Center, San Francisco Public Library.)

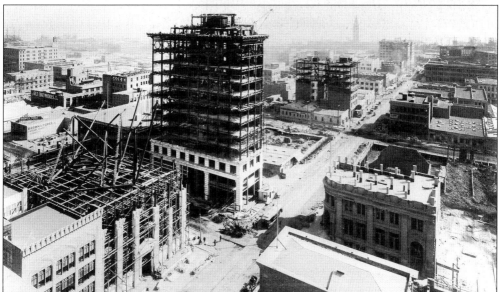

CALIFORNIA STREET. This photograph of California Street from Front and Sansome Streets shows the amount of reconstruction to the Financial District about a year after the disaster. The Bank of California is the building under construction on the lower left. The building at the center of the photograph is the Alaska Commercial Building (1908–1975). (Courtesy of the California Historical Society.)

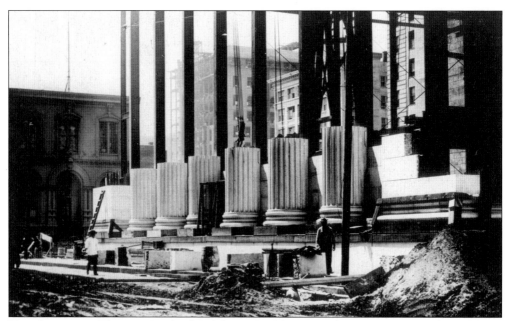

THE COLUMNS. The new Bank of California Building is under construction. The old bank was not lost in the earthquake and fire because it had already been torn down to make way for a new one. The sections of the granite columns seen here had to be transported by 18-horse teams through the streets of the Financial District, then hoisted into place. (Courtesy of the Union Bank of California.)

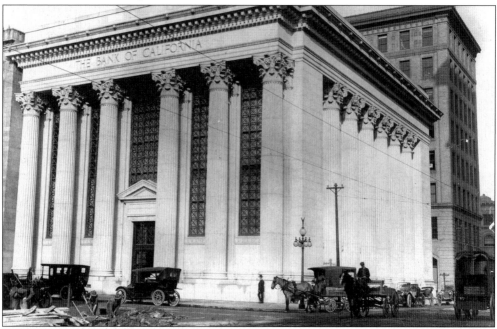

THE GRAND OLD LADY OF CALIFORNIA STREET. The new four-story Bank of California Building took two years to build, but it was the first new commercial structure of the post-earthquake Financial District. It opened on September 8, 1908, and is still in use. (Courtesy of the San Francisco History Center, San Francisco Public Library.)

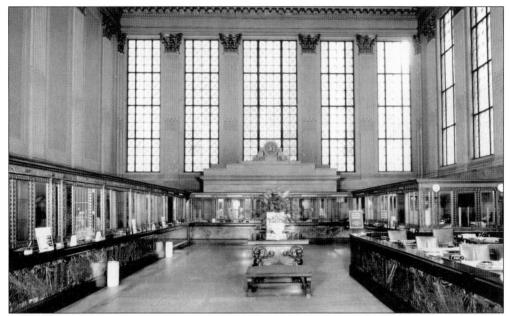

Main Banking Hall of the Bank of California. The four-story main banking hall of the Bank of California has 16 35-foot windows that allow light on three sides of the building and emphasize the coffered, gold leaf ceiling. The bronze grills at the teller stations were later removed and reworked into stairway railings and safe deposit trim. The lion clock at the end of the room was sculpted by Arthur Putnam. (Courtesy of the Union Bank of California.)

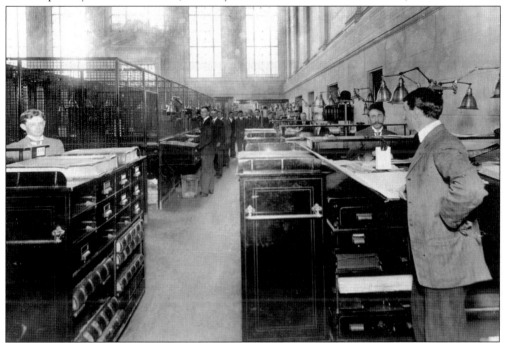

Bank Employees Behind the Counter. This informal 1911 photograph of employees behind the bronze grills of the counter of the Bank of California was taken by an unidentified photographer. (Courtesy of the Union Bank of California.)

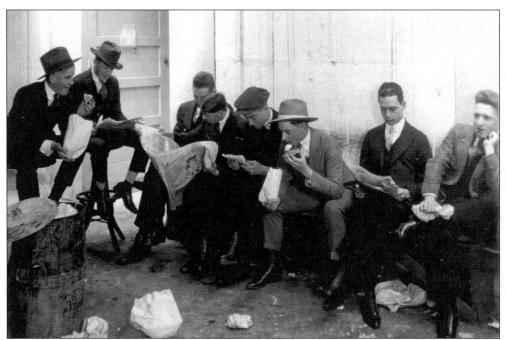

BANKERS AT LUNCH. In 1912, this informal group of unidentified Bank of California employees enjoy their lunch break. (Courtesy of the Union Bank of California.)

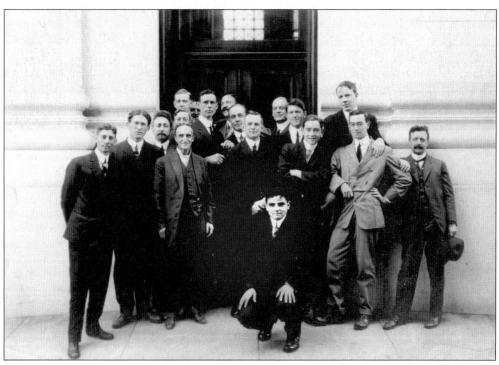

EMPLOYEES IN FRONT OF THE BANK OF CALIFORNIA. Also in 1912, these unidentified Bank of California employees stand in front of the building. (Courtesy of the Union Bank of California.)

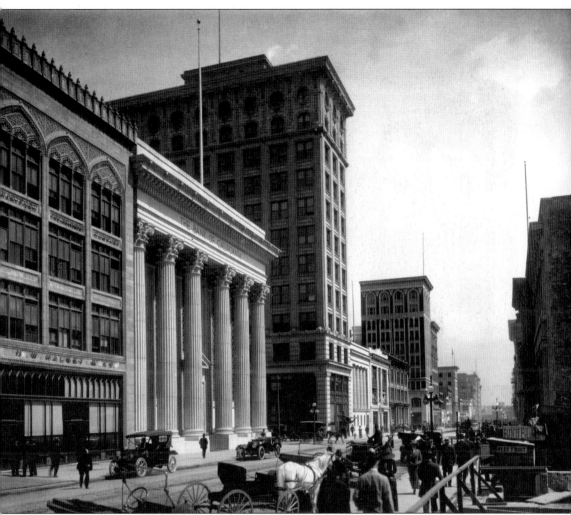

CALIFORNIA STREET AND THE ALASKA COMMERCIAL BUILDING. Ten years after the earthquake and fire, this photograph of California Street near Sansome shows the amount of reconstruction that had taken place. The Bank of California is on the left. The tall building in the center is the Alaska Commercial Building. The Alaska Commercial Company was founded in 1868 by several San Francisco Jewish businessmen and other entrepreneurs. The company is credited with helping to open the Alaska Territory to settlers and businesses after Alaska was purchased from Russia by the United States. They operated village stores there that were often the center of tiny, remote communities. The Alaska Commercial Company was in the business of seal hunting, fur trapping, salmon fishing, trading, and land speculation. The company is no longer located in San Francisco and has changed over the years. Today it is Alaska's largest rural retailer, owned by the Northwest Company. (Courtesy of the Union Bank of California.)

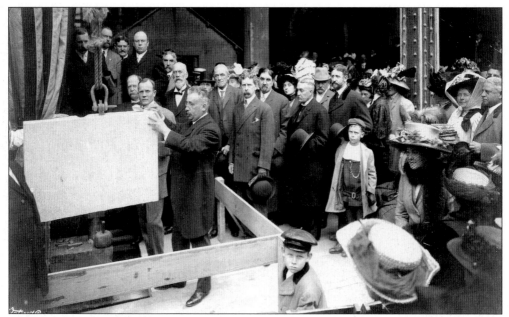

LAYING THE CORNERSTONE. In 1909, the ceremony of laying the cornerstone of the new Mechanics' Institute Library at 57 Post Street took place. The man with his hands on the cornerstone is institute president Rudolph J. Taussig. Albert Pissus, the architect, is in the center, holding his hat. He was also the architect of the Flood Building and the Hibernia Bank Building. (Courtesy of the Mechanics' Institute Library.)

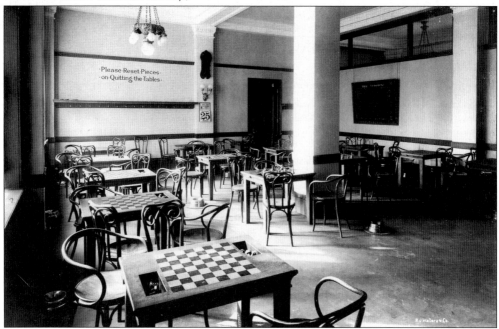

PLEASE RESET THE PIECES ON QUITTING THE TABLES. The Mechanics' Institute Chess Club, established in 1854, is the oldest continuously operating chess club in the United States. The tables seen here c. 1914 are still in use. The silver spittoons are not. The previously all-male club now allows women and junior players. (Courtesy of the Mechanics' Institute Library.)

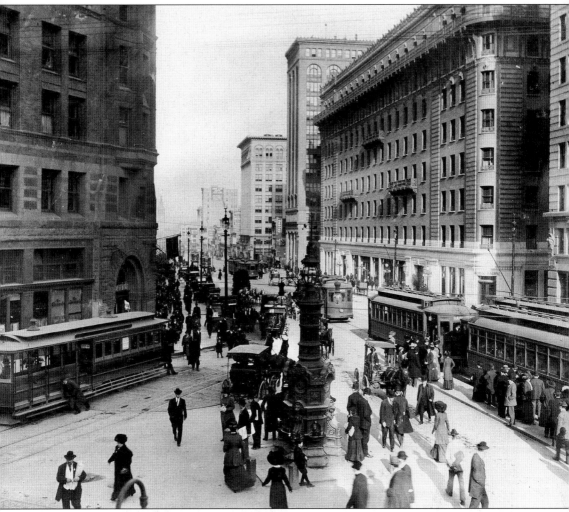

MARKET STREET AND THE NEW PALACE HOTEL. This photograph of commuters on Market Street, taken sometime around 1910, shows the busy intersection of Kearny and Geary Streets at Market Street. Lotta's Fountain is at the forefront of the photograph and behind it is the Chronicle Building. On the right is the Palace Hotel at 633-665 Market Street, built on the site of the first hotel, which was lost in the 1906 disaster. The new Palace was built by the architectural firm of Trowbridge and Livingston in 1909. It was built along similar lines as the old hotel but did not include the grand carriage entrance. The most prominent feature of the new Palace Hotel was its Garden Court. The building next to the hotel is 623-631 Market Street, which still stands today. (Courtesy of the San Francisco History Center, San Francisco Public Library.)

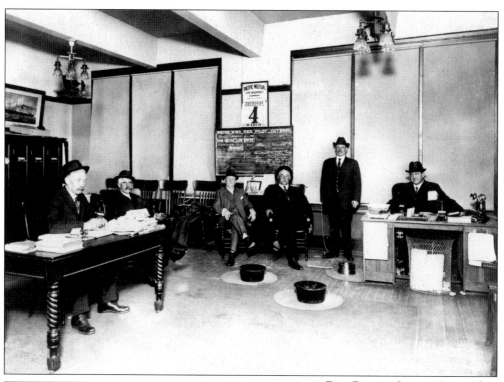

BAR PILOTS OFFICE. Pictured here on March 4, 1915, in the San Francisco Bar Pilots office in the Ferry Building, from left to right, are Swanson, McCulloch, Miller, Christenson, Gielow, and G. Wallace Jr. Note the two large spittoons on the floor. (Courtesy of the San Francisco Bar Pilots Association.)

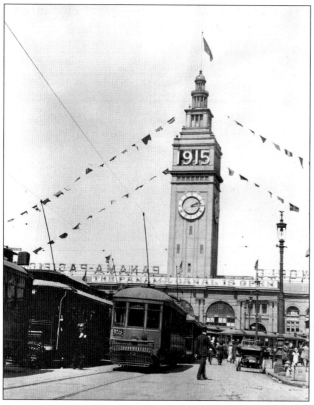

PANAMA PACIFIC INTERNATIONAL EXHIBITION OF 1915. The Ferry Building is pictured here with a banner announcing, "The Panama Canal is Open." The 1914 opening of the canal considerably shortened the time it took for vessels to travel to San Francisco. The decorations for the Panama Pacific International Exhibition are also seen here. (Courtesy of the San Francisco History Center, San Francisco Public Library.)

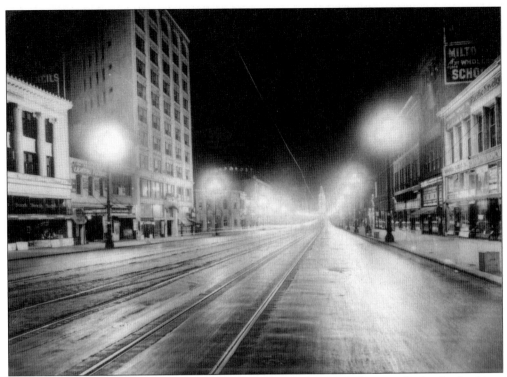

The Path of Gold. On October 4, 1916, the Path of Gold streetlights were lit for the first time on Market Street. (Courtesy of Pacific Gas and Electric Company.)

Path of Gold Streetlights. One of the more practical results of the City Beautiful Movement was the beautification of streetlights. New streetlights, designed by Daniel Burnham and Company, were originally put up in 1908, but were redesigned with three lamps each in 1916–1917. The architect was Willis Polk and the sculpture at the base depicting "the winning of the west" was done by Arthur Putnam. (Courtesy of Pacific Gas and Electric Company.)

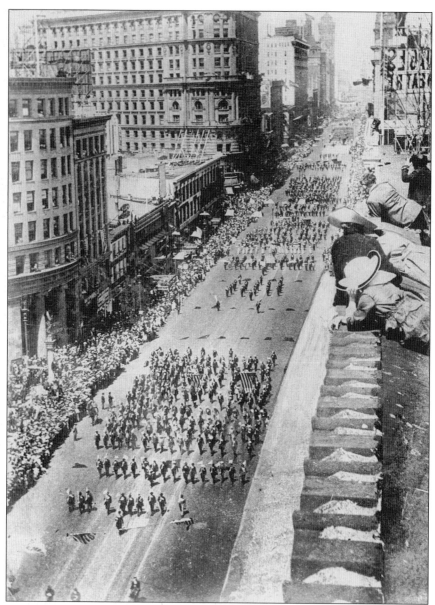

1917 PREPAREDNESS DAY PARADE. The goodwill generated by the Panama Pacific International Exhibition was overshadowed by labor upsets and the start of World War I in Europe in 1914. The possible entry of the United States into war had a divisive impact on the community. The Preparedness Day Parade was planned to show support for the military in the possibility of U. S. entry into the war. On July 22, 1917, the parade began making its way down Market Street with Mayor Rolph and local business leaders leading 20,000 marchers. At 2:04 p.m., a bomb exploded on Steuart Street near Market Street killing nine people and injuring 40. Five radical union activists were arrested as suspects and a case was quickly built against them. Warren K. Billings was convicted and sentenced to life in prison. Thomas J. Mooney was convicted and sentenced to death. The other three were not convicted. This photograph was used in Mooney's trial to prove he was on a rooftop at Fifth and Market Streets at the time of the bombing. (Courtesy of the San Francisco History Center, San Francisco Public Library.)

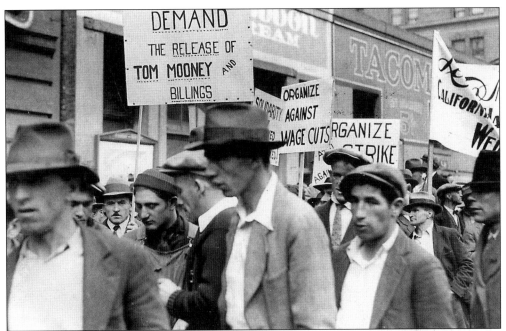

MOONEY-BILLINGS PROTESTS. The Preparedness Day bombing trial caused considerable controversy. Demonstrations against Mooney's execution were held worldwide. In 1939, Mooney and Billings were freed. Billings received a pardon in 1961. (Courtesy of the San Francisco History Center, San Francisco Public Library.)

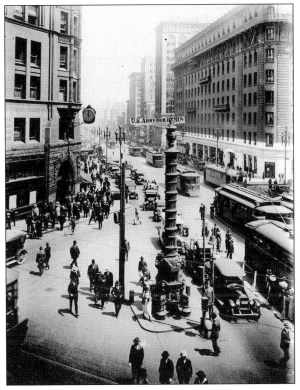

MARKET STREET. This photograph of Market Street at the intersection of Kearny, Geary, and Market Streets during World War I shows numerous streetcars in operation and relatively few automobiles. The banner spread across Market Street reads "U.S. Army Builds Men—Enlist at 660 Market St." (Courtesy of the San Francisco History Center, San Francisco Public Library.)

130 Bush Street. Built in 1910, this tiny skyscraper was designed by MacDonald and Applegarth. Known as either the Heineman Building or the Liberty Mutual Building, the structure is 10 stories tall and 20 feet wide. (Christine Miller photograph.)

The Hallidie Building, 2005. The Hallidie Building at 130 Sutter Street was, in 1917, the world's first structure with a glass curtain wall. The building was designed by architect Willis Polk for the University of California. It was named for Andrew S. Hallidie, inventor of the cable car and a UC Regent. (Christine Miller photograph.)

Seven

A NEW LANDSCAPE

During reconstruction, the Financial District was restored along the same pattern as before, with California and Montgomery Streets as the central roads of the neighborhood. The new downtown area was different in that the retail area moved into Union Square and the warehouse district shifted south. The buildings constructed in the Financial District during this period were not much taller than before and were actually lower than in most other major cities. That changed in the 1920s with a building boom that created dramatic new structures. The Robert Dollar Building was the first significant building to be constructed after World War I. In the late 1920s, the Pacific Telephone Building, the Hunter-Dulin Building, and the Russ Building changed the skyline significantly. The boom ended with the stock market crash of 1929.

In the 1930s, the Great Depression meant a rise in unemployment and fewer new structures in the downtown area. Buildings were remodeled instead to save on costs. One of the more powerful events within the Financial District during the 1930s was the 1934 Longshoreman's Strike, which closed all of the ports on the West Coast. In 1937, both the Golden Gate Bridge and the Bay Bridge opened and permanently changed transportation patterns into the Financial District. During World War II, there was little new construction and the skyline remained unchanged. One important change during the Second World War was the entry of women into the work world.

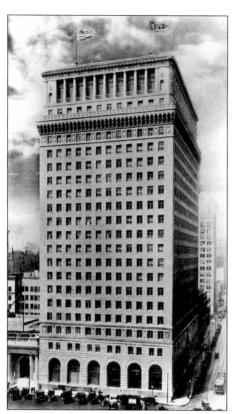

STANDARD OIL COMPANY BUILDING. The second of the four Standard Oil Company buildings in the Financial District is 225 Bush Street, designed by George Kelham and constructed in 1922. Originally the building was L-shaped, but a 1948 addition created a U-shaped building. (Courtesy of the San Francisco History Center, San Francisco Public Library.)

HUNTER-DULIN BUILDING (111 SUTTER STREET). One of the Financial District's more interesting buildings, and one that adds considerable grace to the skyline, is 111 Sutter Street. The 22-story building was designed by the New York firm of Schultze and Weaver and constructed in 1926. The building has a mix of Romanesque and French Chateau ornamentation and is the only one of its kind in San Francisco. (Courtesy of the San Francisco History Center, San Francisco Public Library.)

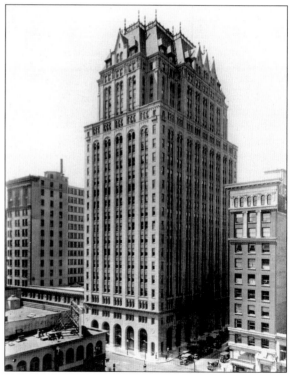

RUSS BUILDING. The 31-story Russ Building, designed by George Kelham and constructed in 1927, sits at 235 Montgomery Street. It was the largest building west of Chicago for 30 years, and the first in San Francisco to have an indoor parking garage. It is now a California State Historic Landmark. (Courtesy of the San Francisco History Center, San Francisco Public Library.)

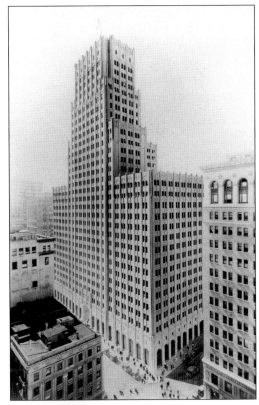

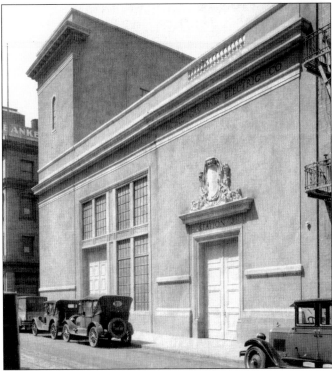

STATION J. Following the example set by the City Beautiful Movement and by Willis Polk's design of Substation C, Pacific Gas and Electric Company became a leader in constructing industrial buildings that were visually pleasing. This photograph shows substation J on Leidesdorff Street in 1927, four years after it was constructed. (Courtesy of Pacific Gas and Electric Company.)

81

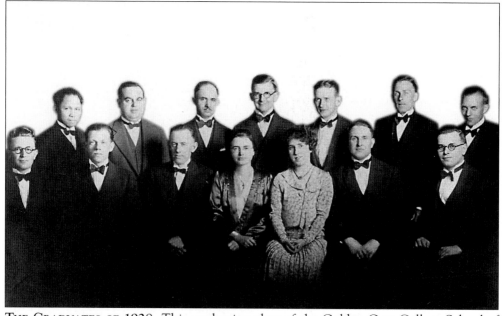

THE GRADUATES OF 1928. This graduating class of the Golden Gate College School of Law, (now Golden Gate University) includes its first two female graduates. (Courtesy of Golden Gate University.)

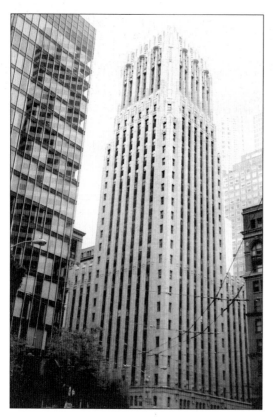

THE SHELL BUILDING, 2005. The Shell Building at the corner of Bush and Battery Streets was designed by George Kelham. Constructed in 1929 for the Shell Oil Company, it is one of Financial District's more beautiful buildings from this era. (Christine Miller photograph.)

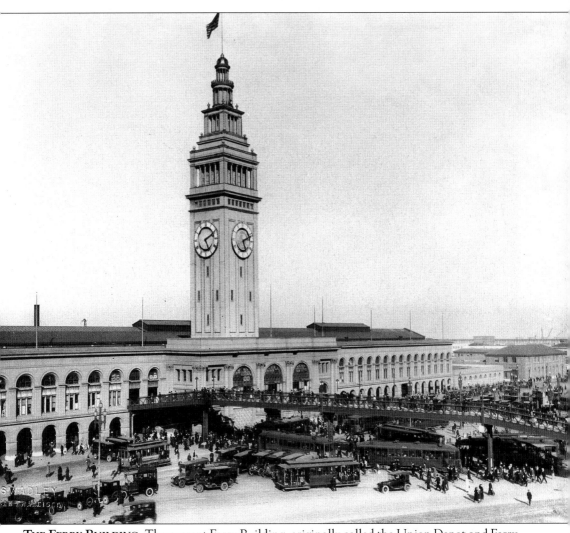

THE FERRY BUILDING. The current Ferry Building, originally called the Union Depot and Ferry House, replaced the earlier Ferry House on the same site. The building, designed by architect A. Page Brown, included a tall clock tower modeled on Seville Cathedral's Giralda bell tower in Spain. Brown died before he could see his building completed, and construction was completed by Edward Swain and chief engineer Howard Holmes. In 1898, the Ferry Building opened. It withstood the 1906 earthquake with damage only to the tower. The Ferry Building is pictured here sometime in the late 1920s at a time when 50,000 people a day commuted by ferry. Prior to the construction of the Bay Bridge and the Golden Gate Bridge, the Ferry Building was the central transit hub of the Financial District. (Courtesy of the San Francisco History Center, San Francisco Public Library.)

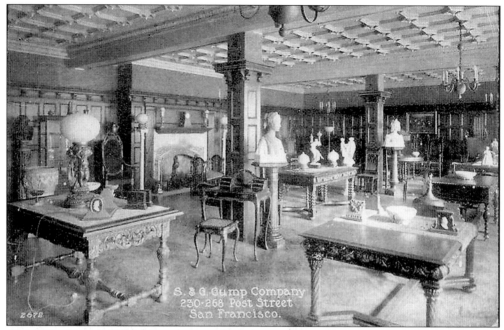

GUMP'S INTERIORS. These two photographs, taken sometime between 1915 and 1930, show the interior of S. and G. Gump's store at 230-268 Post Street. Though Gump's began its business selling mirrors and moldings, they gradually became expert in European, Japanese, and Chinese antiques and fine arts. The top photograph shows a display of European antiques. The bottom photograph features Oriental antiques. Gump's Post Street store was presided over by A. L. Gump who was known for his genial attention to customers and his ability to tell an intriguing story about items for sale in the store. He personally looked after all important guests who visited the store. One company story from this era tells of actress Lily Langtree's visit. A. L. Gump presented a jade necklace that he intended to sell to her but made a mistake in his phrasing by saying, "Miss Lily, this necklace is for you." She thanked him, pocketed the necklace, and left. (Courtesy of Gump's.)

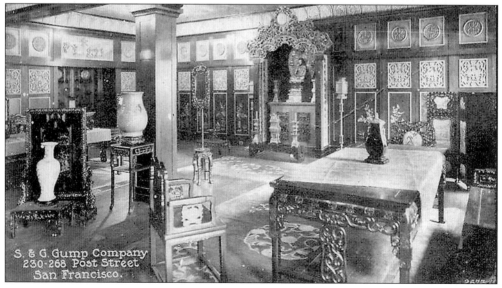

A. P. GIANNINI (1870–1949).
The founder of the Bank of Italy
and one of the most influential
bankers of the 20th century was
A. P. Giannini. Not afraid to
be unconventional, he was the
initiator of branch banking in
the United States and focused on
serving immigrants
and working class people.
(Courtesy of Bank of America;
copyright 2005 Bank of
America, N. A.)

TYPING CLASS. Probably taken
in the 1920s, this undated
photograph shows Heald College
students in typing class. (Courtesy
of Heald College.)

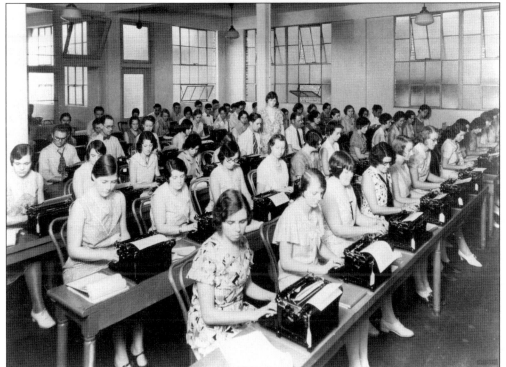

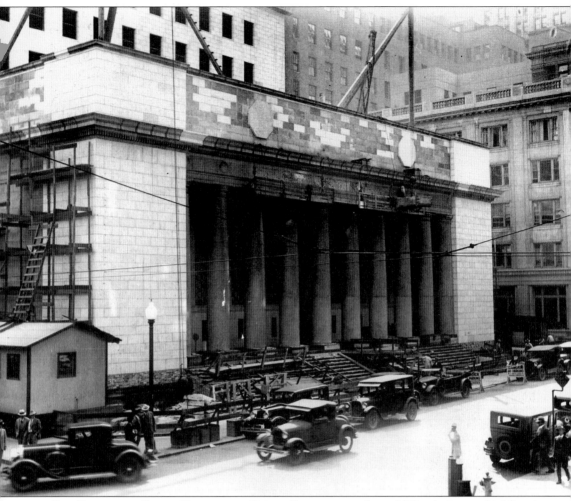

SAN FRANCISCO STOCK EXCHANGE. Originally constructed as a U.S. subtreasury building in 1915, architects Miller and Pflueger were hired in 1928 to convert it for use by the San Francisco Stock Exchange (now the Pacific Coast Stock Exchange). The old treasury building was redesigned and two towering Ralph Stackpole sculptures were added to the front. This building was the main trading hall. Behind it is 155 Sansome Street, a 12-story office tower that includes the City Club. The stairwell of the City Club is famous for its Diego Rivera mural. (Courtesy of the San Francisco History Center, San Francisco Public Library.)

THE SAN FRANCISCO CURB EXCHANGE, 1929. Designed by architects Miller and Pflueger and opened in 1923, this building is located at 350 Bush Street. It originally housed the San Francisco Mining Exchange until 1928, when the San Francisco Curb Exchange replaced it. In 1938, the Curb Exchange merged with the San Francisco Stock Exchange. (Courtesy of the San Francisco History Center, San Francisco Public Library.)

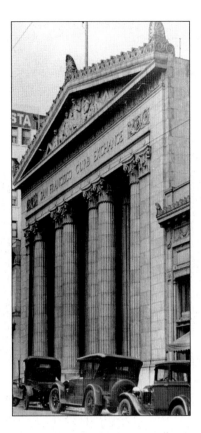

THE GIANT JANITOR. Many Financial District buildings are serviced by American Building Maintenance, a company formed in 1909 when Morris Rosenberg offered window washing to the merchants on Fillmore Street. ABM Industries expanded from window washing to janitorial and a diversity of services. Its lighting division wired the Golden Gate and Bay Bridge. Today ABM is a leader in facility service contracting in the United States. (Courtesy of ABM Industries, Incorporated.)

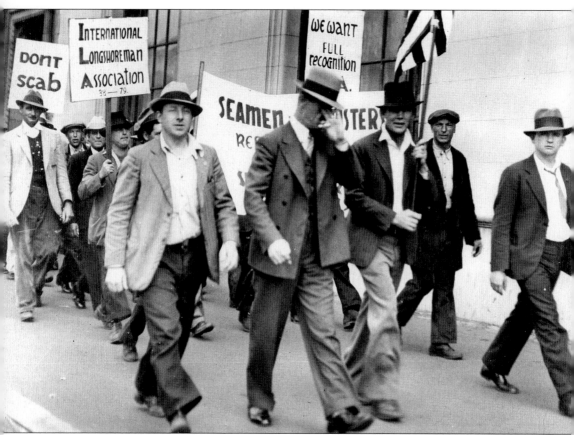

STRIKERS MARCHING. After the earthquake and fire, longshoremen of San Francisco benefited from the boom during reconstruction. By the mid-1910s, the chamber of commerce went to work against union power. The maritime unions were dealt a blow in an unsuccessful strike in 1919 and many years of union decline followed. By the time the Great Depression began, living standards for maritime workers had declined drastically. In 1934, the International Longshoreman's Association held a convention in San Francisco to elect their officials and establish their demands as workers. The strike was briefly delayed with an intervention by President Roosevelt, but an agreement could not be reached. The 1934 Maritime Strike began on May 9, 1934, and closed all of the ports on the West Coast. This photograph of strikers was taken on May 15, 1934. (Courtesy of the San Francisco History Center, San Francisco Public Library.)

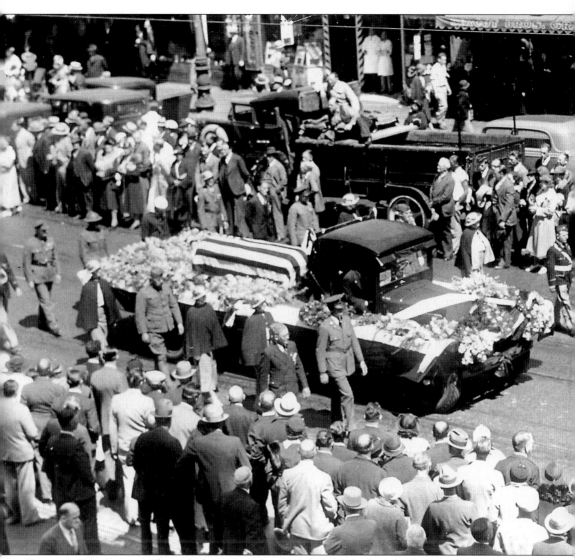

FUNERAL PROCESSION. The strike became violent on July 3, 1934, when the Industrial Association of San Francisco, the employers and businesses that wanted the strike to end, began moving freight from waterfront piers that had been closed since May 9. Violent clashes that included the use of gunfire and tear gas broke out between the police and the strikers. The rioting quieted over the Fourth of July holiday but resumed on July 5, now known as "Bloody Thursday." Two strikers were shot outside of the Audiffred Building and scores were injured. The Embarcadero was swept by intense riots and National Guard troops were called in by Governor Merriam. The funeral cortege for the two men who were shot and killed in the riots, Howard Sperry and Nickolas Bordoise is shown here. The extensive funeral procession began on Steuart Street and proceeded down Market Street with practically every local union represented. Thousands paused to watch the procession. (*San Francisco News* photograph; courtesy of the San Francisco History Center, San Francisco Public Library.)

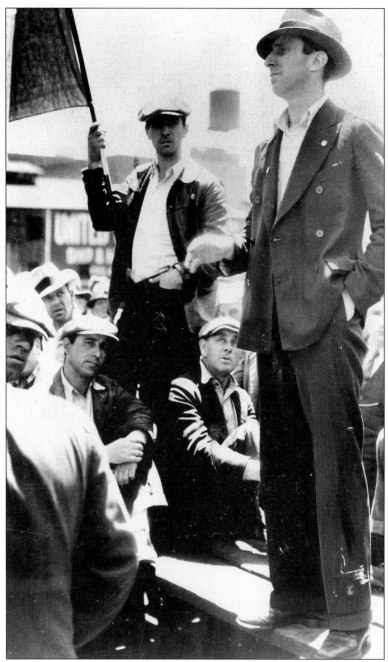

HARRY BRIDGES. On July 9, 1934, International Longshoreman's Association leader Harry Bridges, shown here, told strikers to "stick with it," and even after "Bloody Thursday," a general strike was called for July 16. Unions in San Francisco and Alameda joined the strike for four days. Transit lines did not run. Restaurants and businesses remained closed. The general strike demonstrated the strength of the unions. During the strike, Bridges was denounced as a radical and a communist. Bridges later formed the International Longshoreman's and Warehouseman's Union (ILWU), which he presided over from 1937 to 1977. (Courtesy of the San Francisco History Center, San Francisco Public Library.)

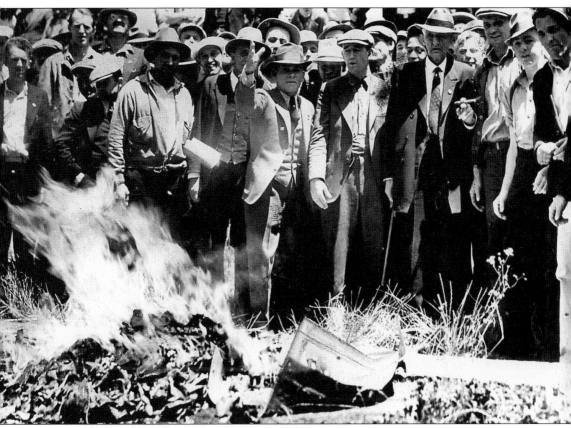

BURNING SEAMEN'S BOOKS. On July 31, 1934, the Longshoreman's Strike ended. The strikers won new standards for maritime workers and established the power of local unions. In this photograph taken on July 30, 1934, strikers are seen burning the "blue books" that once tied them to company-run unions. From 1919 to 1933, workers could only get a job on the waterfront if they had a blue book. The strikers are standing in an empty lot at Clay Street and Embarcadero. To the right of the photograph holding the cigar is Andrew Furuseth of the Sailor's Union of the Pacific, an early advocate for sailor's rights, telling the strikers to burn the books. (Courtesy of the San Francisco History Center, San Francisco Public Library.)

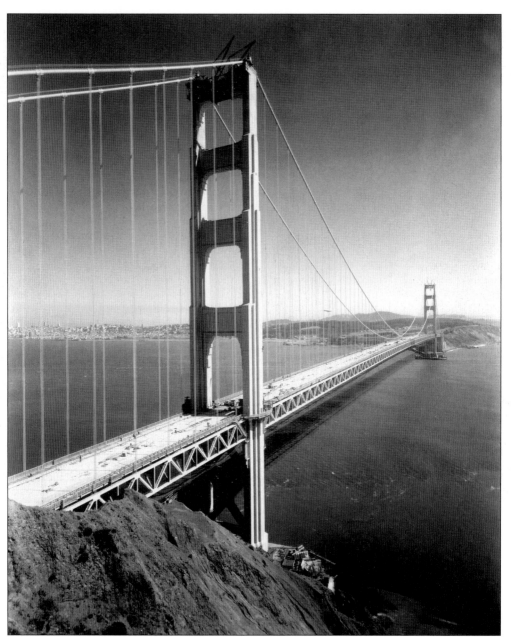

THE GOLDEN GATE BRIDGE UNDER CONSTRUCTION. The Golden Gate Bridge was the bridge that many said could not be built yet it was constructed in just over three years. Construction began in January 1933 and ended in May 1937. At the time, it was the longest suspension bridge ever built and it remained so until 1964, when the Verrazano Narrows Bridge opened in New York with a span that was 60 feet longer. The Golden Gate Bridge has served as a major transportation link between San Francisco's Financial District and the communities of the Redwood Empire to the north. During the first year of its use, 3.3 million cars crossed the span. Today about 40 million cars cross the bridge every year. From the time of its opening in May 1937 to March 2005, 1.8 billion vehicles have crossed the span. (Courtesy of the Golden Gate Bridge, San Francisco, California, www.goldengatebridge.org.)

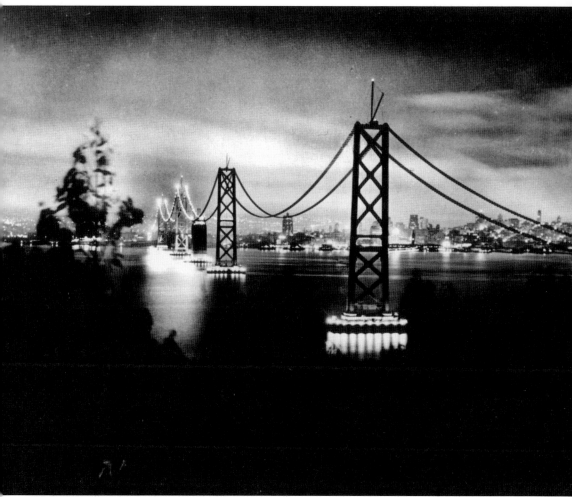

THE BAY BRIDGE. The San Francisco-Oakland Bay Bridge is actually two bridges connected at Yerba Buena Island. The eight-and-a-half-mile bridge was completed after three and a half years of construction. The Bay Bridge opened on November 12, 1936, at a cost $77.6 million. For the first two decades of its use, half of the lower roadway of the bridge was used for train service. The train tracks were removed in 1958. Today more than 280,000 vehicles cross the Bay Bridge every day. The Bay Bridge is seen here at night while still under construction. The Financial District in the background. (Courtesy of Pacific Gas and Electric Company.)

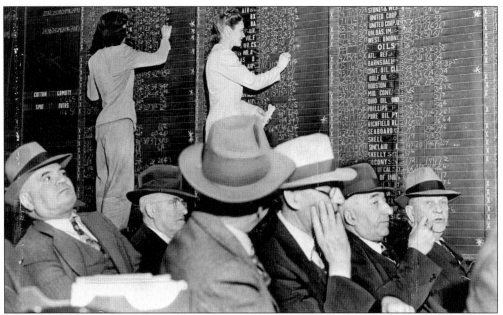

WOMEN AT THE STOCK EXCHANGE. Due to the shortage of men and boys during World War II, the stock exchange business began hiring women. On January 1, 1942, women were allowed to work on the floor of the San Francisco Stock Exchange for the first time. They worked as messengers, board markers, clerks, and recorders. (Courtesy of the San Francisco History Center, San Francisco Public Library.)

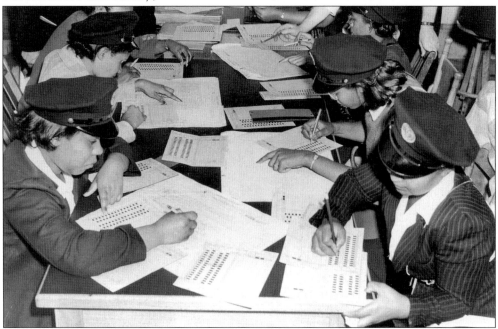

THE TRANSIT WORKERS. During World War II, the worker shortage caused many companies to employ women and minorities in jobs that had not been open to them before. The women pictured here were in training to work as transit conductors, which the city was in desperate need of. (Courtesy of the San Francisco History Center, San Francisco Public Library.)

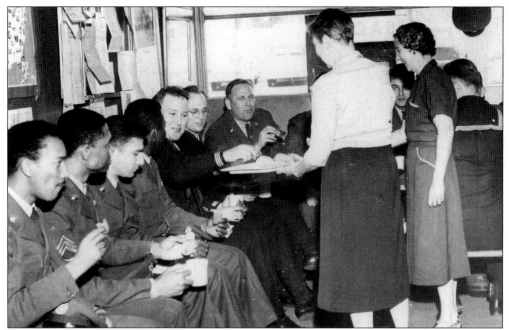

SOLDIERS AT THE FERRY BUILDING. The canteen for visiting servicemen at the Salvation Army Ferry Building offered coffee, doughnuts, and hospitality. Pictured here are Mrs. Alice Fields, right, and Mrs. Gladys Reese of the Sportmen's Unit of the American Legion Auxiliary. (Courtesy of the San Francisco History Center, San Francisco Public Library.)

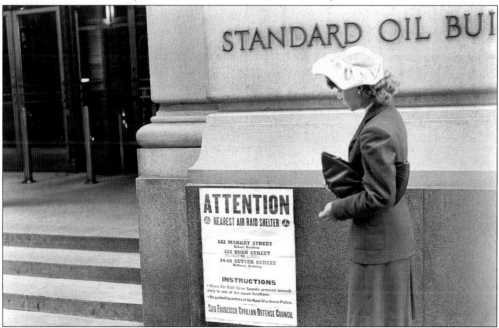

AIR RAID SHELTERS. This photograph shows a young woman pausing to read a sign posted on the side of the Standard Oil Building at 225 Bush Street. The air raid shelters were located in the Hobart Building at 582 Market Street, the Standard Oil Building, and the Holbrook Building at 34-68 Sutter Street. (Courtesy of the California Historical Society.)

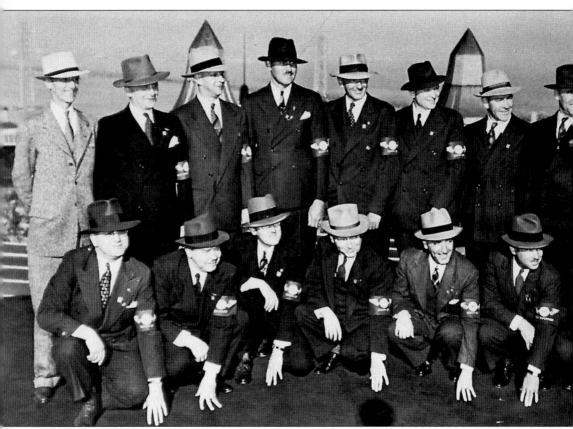

THE AIRPLANE SPOTTERS. During World War II, airplane spotters scanned the skies for enemy aircraft from atop the buildings of the Financial District. Pictured here on August 8, 1943, the group of airplane spotters on the roof of the Russ Building, from left to right, are (first row) Marcel Levy, Joe Underhahl, A. T. Leonard, M. D., Tom Costello, Irving Barnes, and C. Frank Pratt; (second row) H. W. Knowles, R. L. Voight, G. Glosson, Joe Thoman, George I. Hoffman, J. C. Peck, R. L. Duncan, and C. L. Price. This group of men were veteran members of the Aircraft Warning Service and are being honored here for their work. (Courtesy of the San Francisco History Center, San Francisco Public Library.)

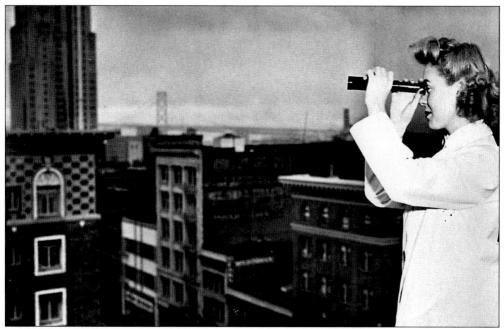

SCANNING THE SKYLINE. In this photograph, airplane spotter Rita Wynn scans the skies with her telescope. Volunteer spotters watched for enemy aircraft from hills and tall buildings throughout San Francisco. (Acme photograph; courtesy of the San Francisco History Center, San Francisco Public Library.)

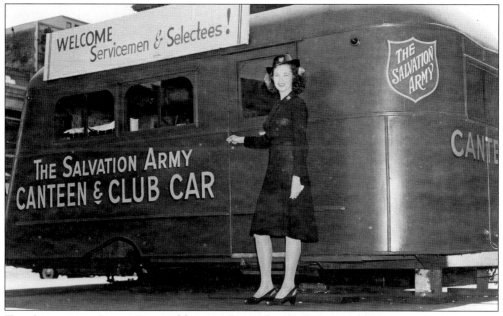

THE SALVATION ARMY. Pictured here in September 1945 is Laurel Watson, one of the many Salvation Army workers who helped the war effort. She is standing in front the canteen located at Battery and Market Streets, not far from an Army Induction Center. The canteen offered information, coffee, and doughnuts. (Courtesy of the San Francisco History Center, San Francisco Public Library.)

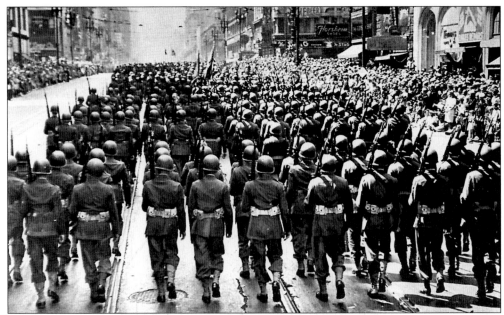

RETURNING SOLDIERS. On August 14, 1945, the Japanese surrendered and World War II ended. Celebrations occurred throughout the city. This victory parade was held on September 10, 1945, and shows a parade of returning soldiers marching down Market Street near the intersection of Kearny and Geary Streets. (Courtesy of the San Francisco History Center, San Francisco Public Library.)

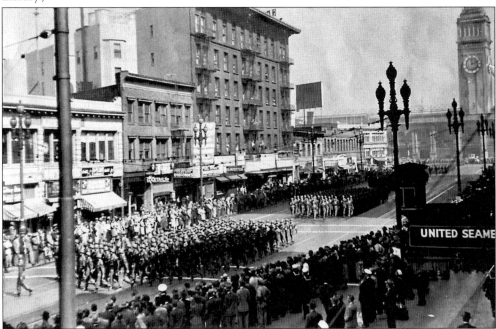

PARADE OF SOLDIERS. A victory parade was held on September 25, 1945, in honor of 80 soldiers who had been held in Japanese captivity for three years. Crowds lined the streets and office workers threw confetti from their windows to greet the returning soldiers. (*Call-Bulletin* photograph; courtesy of the San Francisco History Center, San Francisco Public Library.)

Eight

THE MODERN
WORK WORLD

The Financial District underwent significant changes in appearance in the three decades following the Second World War. In the immediate postwar years, construction was relatively steady. After a lull in the early 1960s, the 34-story Hartford Building at 650 California Street was constructed. It was the tallest building in San Francisco until 1966, when the 43-story Wells Fargo Building at 44 Montgomery Street was constructed. Shortly afterwards, the 52-story Bank of America Center became the tallest building but was swiftly outdone by the Transamerica Pyramid in 1972. In response to this, there was growing opposition against high-rise development in the 1960s and 1970s, which culminated in the passage of Prop M in 1986.

The changes during this period, however, were not limited only to the buildings. Computers were mass produced for the first time in the 1950s, but only large companies could afford them at first. The women's movement and the civil rights movement brought women and minorities into professional positions that had not been open to them before. Transportation routes into the Financial District changed again during this period. In 1947, the remaining cable car lines were threatened with replacement by diesel buses, but public outcry for their preservation prevented their demise. Increased automobile traffic prompted the construction of more parking garages and the Embarcadero Freeway, which cut off the waterfront from the Financial District in 1959. In the 1960s, the construction of the BART system and the Transbay Tube created a new transit option for commuters from the East Bay.

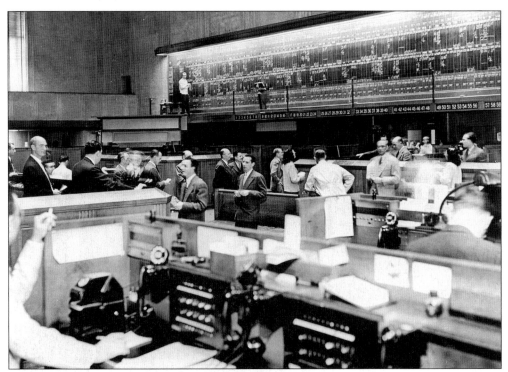

WALL STREET OF THE WEST. This 1946 photograph shows the interior of the Pacific Stock Exchange at the end of a busy day of trading. (International News photograph; courtesy of the San Francisco History Center, San Francisco Public Library.)

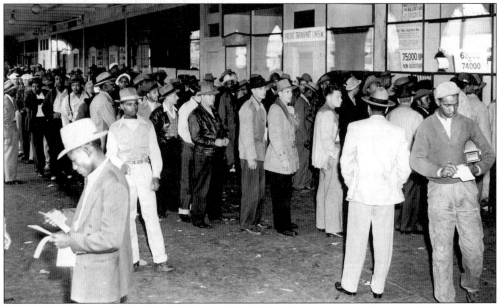

LONGSHOREMAN AT THE FERRY BUILDING. One of the results of the 1934 Maritime Strike was the inclusion of minorities into the unions. This photograph of longshoremen lining up at the Ferry Building to collect retroactive pay increases shows the difference in the racial balance from earlier photographs. (Courtesy of the San Francisco History Center, San Francisco Public Library.)

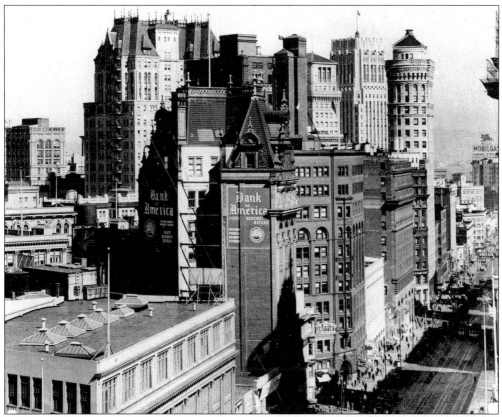

POSTWAR SKYLINE. Pictured in this 1947 Financial District skyline, from left to right, are the Hunter-Dulin Building, Standard Oil Building, the Shell Building, and the Hobart Building. At the front of the photograph is 704 Market Street; behind is the Chronicle Building. (Courtesy of the San Francisco History Center, San Francisco Public Library.)

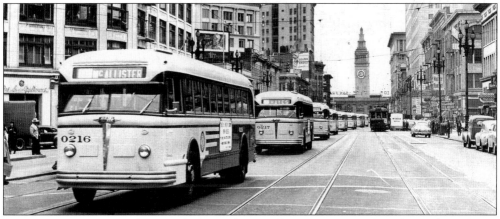

THE BUSES. This 1948 photograph shows the new fleet of buses purchased in order to begin replacing the streetcar lines. Note the four sets of streetcar tracks that Market Street once had. As more people commuted by car, there was a decrease in public transit use. (Courtesy of the San Francisco History Center, San Francisco Public Library.)

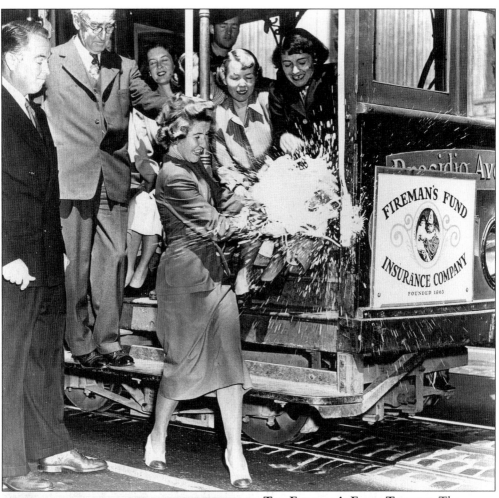

THE FIREMAN'S FUND TROLLEY. The campaign to save the cable cars in 1947 ultimately preserved the three cable car lines that exist today. In this 1949 photograph, a trolley is being christened the "Fireman's Fund." The insurance company "adopted" the trolley to provide financial assistance to the cable car company. (Courtesy of the San Francisco History Center, San Francisco Public Library.)

BLOOD DRIVE. An April 7, 1952, blood drive for the benefit of the Armed Forces in the Korean War takes place at PG&E headquarters at 245 Market Street. (Courtesy of Pacific Gas and Electric Company.)

PARADE ON MONTGOMERY STREET. On July 31, 1953, Gen. Mark Clark is welcomed back from Korea in a parade down Montgomery Street. (Courtesy of the San Francisco History Center, San Francisco Public Library.)

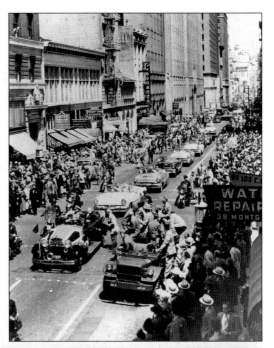

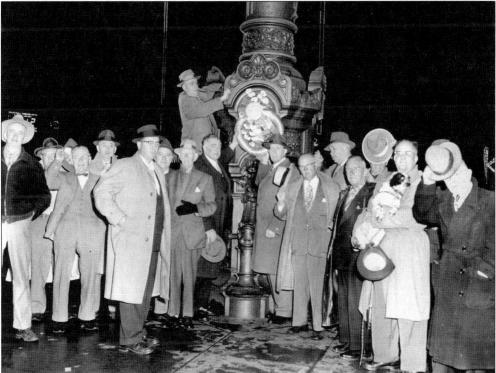

ANNIVERSARY AT LOTTA'S. In 1957, the annual celebration of the 1906 earthquake and fire anniversary takes place. The early morning celebration is held at Lotta's Fountain at Third and Market Streets. The tradition of celebrating the anniversary of the quake is still followed today. (Courtesy of the San Francisco History Center, San Francisco Public Library.)

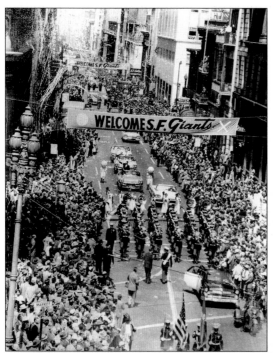

WELCOMING THE SAN FRANCISCO GIANTS. On April 13, 1958, thousands of baseball fans lined Montgomery Street to welcome the Giants to San Francisco. Mayor George Christopher, standing in the car, is credited with bringing the Giants to San Francisco from New York. (Courtesy of the San Francisco History Center, San Francisco Public Library.)

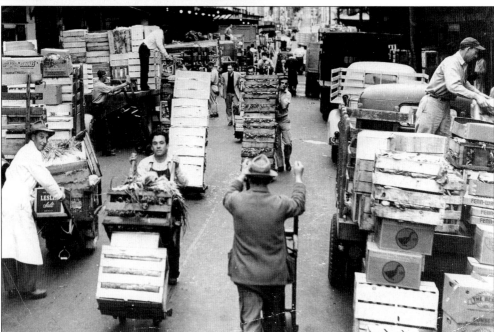

THE OLD PRODUCE DISTRICT. The area on Washington Street between Front, Drumm, and Davis was once a wholesale produce district. In the 1960s, implementation of the Golden Gateway Redevelopment Project led to the construction of the Golden Gateway buildings, the Alcoa Building, and the Embarcadero Center. The spirit of the Produce District lives on at the Ferry Building's Farmer's Market. (Courtesy of the San Francisco History Center, San Francisco Public Library.)

CROWN ZELLERBACH BUILDING.
The Crown Zellerbach Building
was completed in 1959 and
became San Francisco's first
glass-walled tower. The building
was designed to face away from
Market Street, which was in a
period of decline at the time
and towards the center of the
Financial District. (Courtesy
of the San Francisco History
Center, San Francisco
Public Library.)

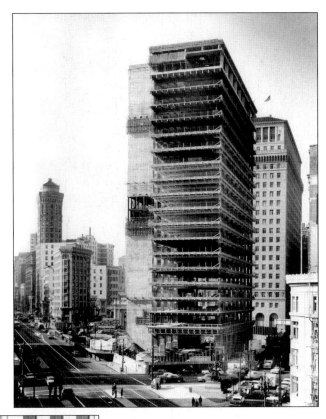

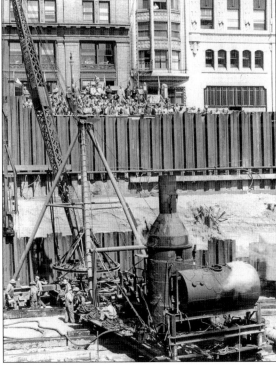

**THE SIDEWALK SUPERINTENDENT'S
CLUB, 1958.** There was so much
interest in the Crown Zellerbach
Building (1 Bush Street) when it was
being constructed that a stand of
bleachers was put up to accommodate
the "Sidewalk Superintendent's Club."
(Courtesy of the San Francisco History
Center, San Francisco Public Library.)

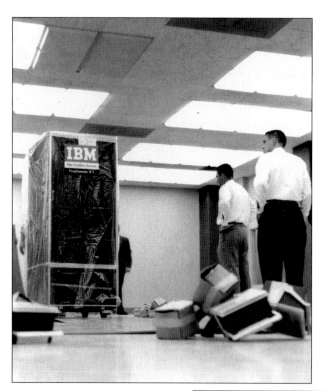

THE NEW COMPUTER. A new 1958 IBM computer waits to be unwrapped and installed in PG&E's new computer center. Computers were mass-produced for the first time in the 1950s but were only to be found in government buildings, large corporations, and universities. (Courtesy of Pacific Gas and Electric Company.)

FAREWELL TO THE OLD YEAR. In 1960, Elizabeth Lambert is tossing her desk calendar and the contents of her hole punch machine to the winds of the Montgomery Street canyon. For years, this was a New Year's Eve tradition in the Financial District. Today the tradition is only followed by a stubborn few. (Courtesy of the California Historical Society.)

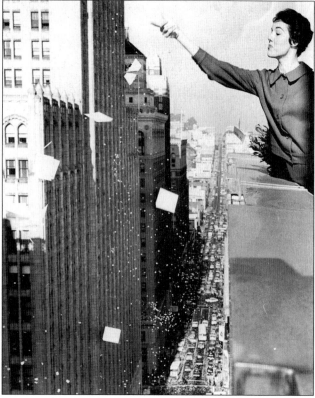

44 MONTGOMERY STREET. Constructed in 1967, 44 Montgomery Street was the largest building west of Dallas until the Bank of America Center was constructed. The 43-story building was formerly the headquarters of Wells Fargo. (Christine Miller photograph.)

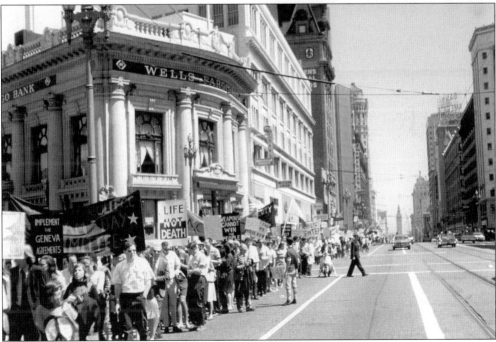

VIETNAM PROTEST. This photograph shows a march on August 6, 1966, protesting American participation in the Vietnam War. An estimated 3,000 people marched from Market and Drumm Streets to Civic Center. The march was sponsored by a coalition of 30 antiwar organizations. (John Ungaretti photograph; courtesy of Lorri Ungaretti.)

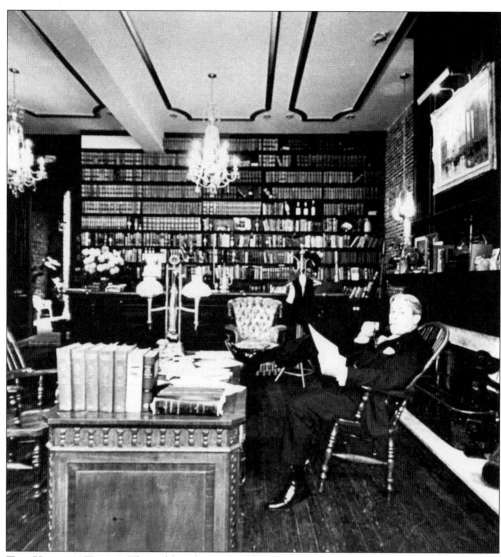

THE KING OF TORTS. The gold rush–era building at 728 Montgomery Street was the site of California's first Masonic Lodge, but it wasn't until flamboyant attorney Melvin Belli moved in that tourist buses made the building a mandatory stop on their tours. The office design was reminiscent of a brothel and decorated with items he had collected during his travels. Belli often raised the Jolly Roger on the flagpole above his building when he won a case, and lowered it when he lost. In this photograph from a 1961 issue of *Holiday* magazine, Melvin Belli (1907–1996) is pictured in his office at the Belli Building. Melvin Belli was an early advocate of consumer rights. He was known as the "King of Torts" because of his work representing personal injury cases and raising the awards in these cases to new standards. He was also known for his use of demonstrative evidence, in which he would illustrate the nature of his client's injuries using whatever props, photographs, or scale models were necessary to make his point. (Courtesy of the San Francisco History Center, San Francisco Public Library.)

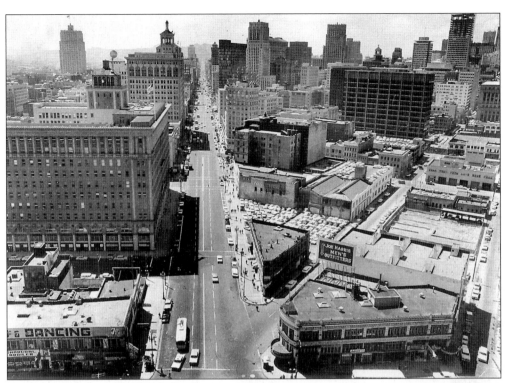

MARKET STREET, 1964. Herb Caen wrote in the *San Francisco Chronicle*, June 14, 1964, "Market Street is the city in all its desperate vitality and glorious vulgarity—the Alcatraz of streets. It's there, but nobody knows what to do with it. Every traffic plan runs up against it and falls back, defeated . . . It is wide, long, stubborn and unregenerate—a true brute of a street. A dead end with a life of its own." (Courtesy of the San Francisco History Center, San Francisco Public Library.)

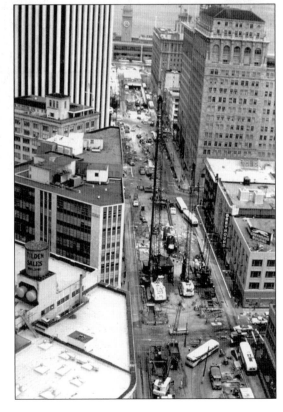

BART CONSTRUCTION ON MARKET STREET, 1968. In a joint venture, Bechtel began design and construction of what was then the first modern transit system in America in 30 years. The original system consisted of 71 miles of commuter rail line through 4 counties and 16 cities, including subways and tunnels, aerial and at grade lines, and a 3.6-mile tube under San Francisco Bay. (Courtesy of and copyright © Bechtel Corporation.)

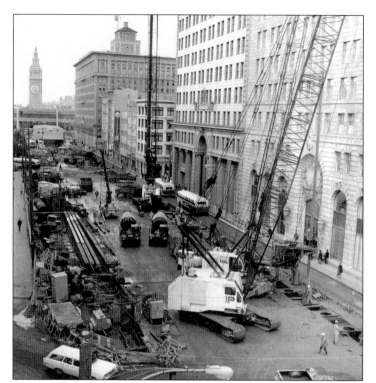

LOWER MARKET DURING BART CONSTRUCTION. This photograph, taken from 320 Market Street on November 7, 1969, shows BART construction crews in the area where the Embarcadero Station is now. The subway tunnels were built 80 to 100 feet below Market Street under extremely difficult conditions. In 1972, BART began service. It was one of the first fully automated and computer controlled transit systems. (Courtesy of Pacific Gas and Electric Company.)

MARKET STREET DISRUPTED. To build BART, extensive amounts of construction and disruption took place on Market Street, as seen here on November 7, 1969. (Courtesy of the Pacific Gas and Electric Company.)

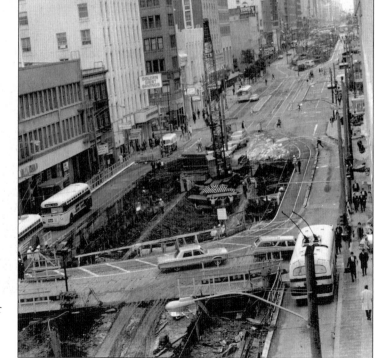

THE TRANSBAY TUBE. The primary difficulty of the BART project was the construction of a 3.6-mile tube on the floor of the bay. The tube ran under the Ferry Building and across the bay to Oakland. It was constructed in 330-foot sections. The platforms seen here were in preparation for trench work for the tube. (Courtesy of and copyright © Bechtel Corporation.)

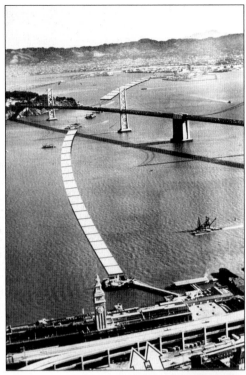

THE VAILLANCOURT FOUNTAIN, 2005. The Vaillancourt Fountain in Justin Herman Plaza was created by the French-Canadian artist Armand Vaillancourt. The fountain debuted in 1971 and has been the object of criticism ever since. Loved by some, but not all, the fountain has its own unique charm. (Christine Miller photograph.)

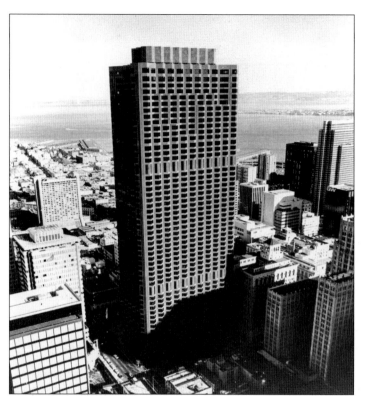

THE BANKER'S HEART. The polished black granite sculpture by Masayuke Nagare in front of the Bank of America Center is commonly referred to as "The Banker's Heart." (Christine Miller photograph.)

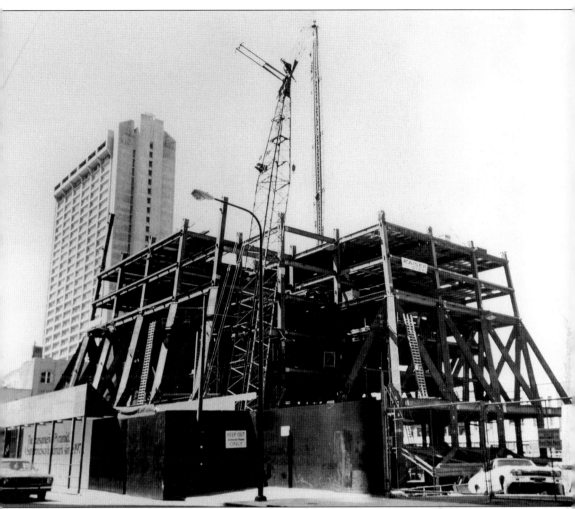

TRANSAMERICA PYRAMID CONSTRUCTION, 1971. When the plan for the Transamerica Pyramid Building was unveiled in 1968, many people were opposed to the design and felt that it was inappropriate for the city. It has since become an icon of San Francisco. William Pereira and Associates began construction in 1969 and completed the building in 1972, the same year the first tenants moved in. The Pyramid is 853 feet high, and its tapered design allows more sunlight to reach the streets below. Once the tallest building in America west of the Mississippi, it remains the tallest building in San Francisco and Northern California. The Transamerica Corporation is no longer headquartered at the Pyramid but remains a tenant there. In this photograph, a billboard on the inside of the walkway of the construction site reads, "The Transamerica Pyramid—A Landmark Since 1972." (Courtesy of the San Francisco History Center, San Francisco Public Library.)

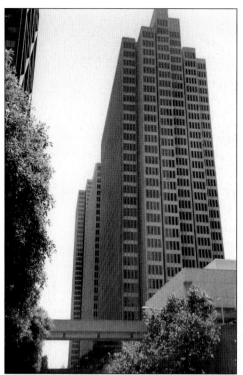

THE EMBARCADERO BUILDINGS. The Embarcadero Center was built in stages. Construction of the four buildings began in 1968 and ended in 1983. Embarcadero West was completed in 1989. The Embarcadero Center consists of five office towers and three interconnected shopping levels. The architect for the five Embarcadero office towers was John Portman and Associates. (Christine Miller photograph.)

SITE OF THE HYATT REGENCY. Pictured prior to the hotel's 1973 completion is the site of the Hyatt Regency. In the background is the Southern Pacific Building at 1 Market Street when it was the only sizable building on the block. The Embarcadero Freeway is on the left. (Courtesy of the San Francisco History Center, San Francisco Public Library.)

THE HYATT REGENCY. Designed by John Portman and Associates, the Hyatt Regency was completed in 1973. The 20-story, 802-room hotel is located at 5 Embarcadero Center. At the top is the only revolving rooftop restaurant in Northern California. It completes a 360-degree turn every 45 minutes. (Courtesy of the San Francisco History Center, San Francisco Public Library.)

INTERIOR OF THE HYATT REGENCY. The interior of the Hyatt Regency has a 17-story atrium with hanging gardens. Mel Brooks prominently featured the unique interior of the hotel in his 1977 film *High Anxiety*. (Courtesy of the San Francisco History Center, San Francisco Public Library.)

THE WALRUSES. Despite desire to preserve the Alaska Commercial Building for its beauty and historical importance, it was torn down in 1975, and the California First Bank Building (370 California Street) replaced it. The granite walrus heads that once graced the Alaska Commercial Building were retained as ornamentation. It is now a Union Bank of California Building. (Christine Miller photograph.)

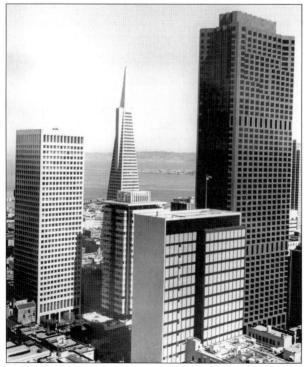

MANHATTANIZATION. The new and sometimes bland high-rises of the Financial District were not without opposition. Numerous campaigns to stop them culminated in the passage of Proposition M in 1986. The citizen-sponsored initiative created the first annual limit on high-rise development in the country. (Courtesy of the San Francisco History Center, San Francisco Public Library.)

Nine

THE NEW CENTURY

In the last two decades of the 20th century and the beginning of the 21st, the Financial District went through numerous changes. In the 1980s, many new office buildings went up and the ongoing fight against those high-rises continued. Antismoking ordinances went into effect and ended smoking in offices. AIDS also became an issue in the workplace during this time. The 1980s saw a rise in the number of homeless on the streets of the Financial District. In 1989, the Loma Prieta earthquake brought changes, including the removal of the Embarcadero Freeway. The 1980s was also the heyday of the Financial District's bike messengers.

In the 1990s, the rapid development of computers and the Internet changed the way business was conducted. The growth of the computer industry in the Silicon Valley caused a dot com boom and then a bust in San Francisco, particularly in the South of Market area. Within the workplace, computers created new ways of doing everything but also created a new isolation among coworkers. The lack of office space and the high cost of living in San Francisco prompted some businesses to leave the area. A number of the Financial District's older businesses were lost as the result of mergers.

Other changes in the Financial District during this period include the renovation of the Ferry Building and the waterfront as well as the establishment of the F-line of historic trolleys.

OLD SHIP SALOON. Since the gold rush, the Old Ship Saloon, at the corner of Pacific and Battery Streets, has continued the tradition of hospitality on that site. The saloon's history began when the ship *Arkansas* was beached there and converted into an ale house. A replica of the old ship hangs above the doorway. (Christine Miller photograph.)

WELLS FARGO ROOF GARDEN. Pictured here is the Wells Fargo Roof Garden, one of two rooftop gardens at the Crocker Galleria between Post and Sutter Streets. One Market Street also has a public rooftop garden as well as 343 Sansome Street. (Christine Miller photograph, 2005.)

THE FEDERAL RESERVE BUILDING. At 101 Market Street is the Federal Reserve Bank of San Francisco. It is one of the regional federal reserve banks that, along with a Board of Governors in Washington D.C., make up the nation's central bank. The Federal Reserve Bank of San Francisco is the headquarters of the 12th reserve. (Christine Miller photograph, 2005.)

THE FEDERAL RESERVE BANK. The Federal Reserve Bank of San Francisco serves nine western states. It manages the supply of money and credit, regulates banking institutions, and serves as a bank for depository institutions and the federal government. Inside the building is the American Currency Exhibit, the most complete collection of American currency on display. (Christine Miller photograph, 2005.)

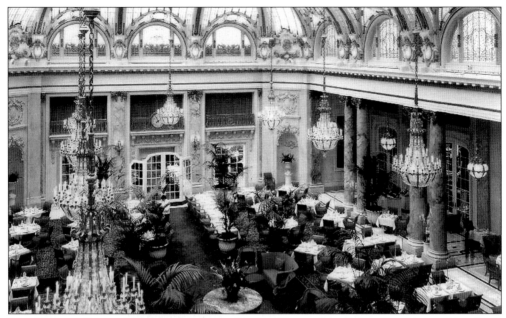

THE GARDEN COURT. Opened in 1909, the Garden Court of the Palace Hotel is considered one the world's most beautiful public spaces, known for its stained-glass ceiling and crystal chandeliers. In January 1989, the Palace Hotel closed for a major restoration. The hotel reopened in 1991, and today the Garden Court remains one San Francisco's most beloved places. (Courtesy of the Palace Hotel.)

ST. PATRICK'S DAY IN THE FINANCIAL DISTRICT. Pictured here is the annual St. Patrick's Day celebration that takes over the portion of Front Street in front of Harrington's Bar and Grill. Celebrating St. Patrick's is a long-standing tradition in the Financial District. (Christine Miller photograph.)

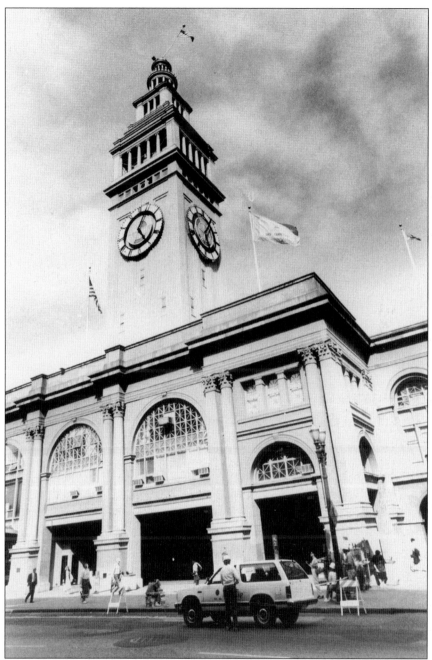

THE LOMA PRIETA EARTHQUAKE. On October 17, 1989, a magnitude 7.1 earthquake shook the Bay Area, causing billions of dollars in damage and killing 67 people. Most of the damage from the earthquake in San Francisco took place in the Marina District. The earthquake stopped the Ferry Building clock at 5:04 p.m. One of the casualties of the quake was the Embarcadero Freeway that had blocked the Ferry Building from view for so many years. The removal of the freeway in 1991 brought new life to the Ferry Building and reconnected the waterfront to the Financial District. The Embarcadero began a transformation that continues to the present day. (Courtesy of the San Francisco History Center, San Francisco Public Library.)

101 California Street Massacre. On July 1, 1993, a disgruntled businessman named Gianni Luigi Ferri arrived at the office of Petit and Martin on the 34th floor of 101 California Street with several guns and opened fire. He killed eight people and wounded six before killing himself in the stairwell. The massacre galvanized the gun-control movement in California. (Christine Miller photograph.)

The General Harrison. Pictured here in September 2001 is the excavation of the *General Harrison* at the corner of Battery and Clay Streets. The gold rush-era store ship was buried for about 150 years until the Yank Sing restaurant above it was torn down. (Christine Miller photograph.)

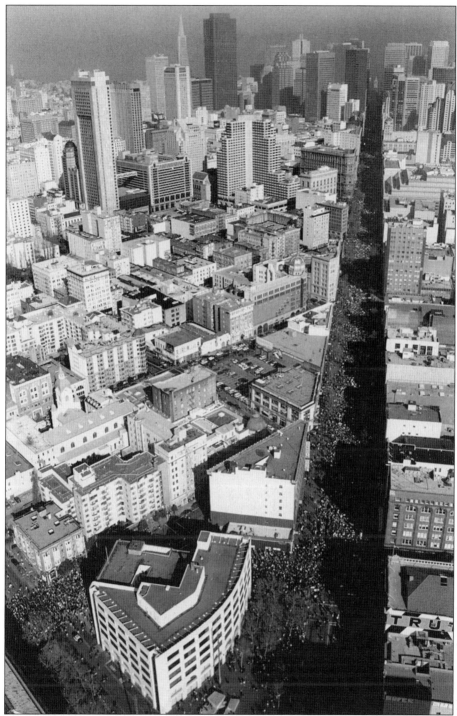

ANTIWAR PROTESTORS ON MARKET STREET. On January 18, 2003, as the United States military prepared to go to war in Iraq, a protest march gathered at the Ferry Building with an estimated 125,000 participants. The crowd stretched from the foot of Market Street to Civic Center. (Photograph by Peter Maiden.)

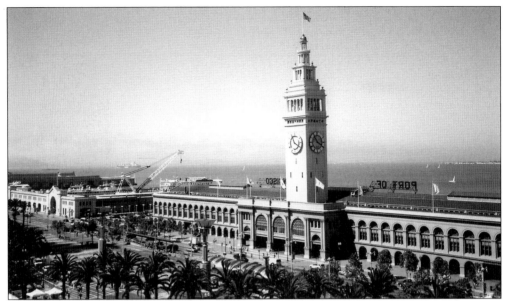

THE FERRY BUILDING RESTORATION. In 2003, the Ferry Building was restored after a four years of work in a public-private collaboration. It has an upscale public food-market on the ground floor and offices on the upper floors. The addition of the F-line of historic streetcars has transformed the area where the Embarcadero Freeway once was. (Christine Miller photograph.)

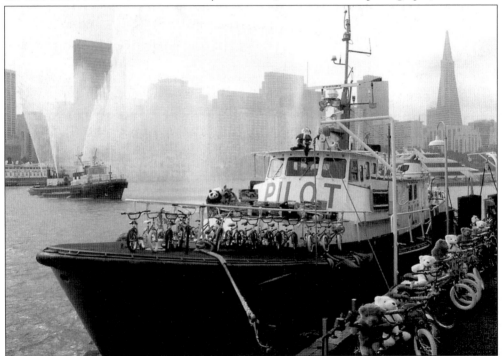

TOY BOAT, 2004. With the Financial District in the background, one of the pilot boats of the San Francisco Bar Pilots is decorated with toys collected for the Toys for Tots program during the Christmas season. The San Francisco Bar Pilots Association is the oldest, continuously operating business in California. (Courtesy of the San Francisco Bar Pilots Association.)

OLD ST. MARY'S. In January 2005, Old St. Mary's celebrated its 150th anniversary. It was California's first cathedral and in 1854, San Francisco's tallest building. It remains a unique landmark on the border of the Financial District and Chinatown and shares in the history of both neighborhoods. (Christine Miller photograph.)

THE CHRONICLE BUILDING. Pictured here in June 2005 is the San Francisco's first skyscraper, 690 Market Street, at the beginning of its renovation. In the 1960s, a metal facade was constructed over the building to modernize it. In this photograph, that facade has been removed from the front entrance to reveal the words "DeYoung Building." (Christine Miller photograph.)

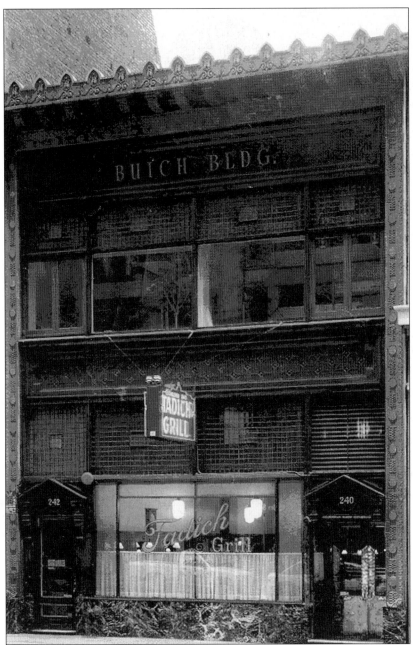

THE TADICH GRILL. Established in 1849 by Croatian immigrants, the Tadich Grill began as a coffee stand on Long Wharf (now Commercial Street) and has served the Financial District for over 150 years. It is San Francisco's and California's oldest restaurant. There have been a few changes of name, but the Tadich Grill has been consistently owned by Croatian-American families. The restaurant has had eight locations since it began serving coffee in a tent. All of its previous locations were located within a small area, at the heart of the Financial District. The Tadich Grill, still considered one the best seafood restaurants in San Francisco, is a favorite among locals. Today the Tadich is located at 240-242 California Street and is owned by the Buich family. (Courtesy of Mike Buich.)

HERB CAEN AT THE MECHANICS' INSTITUTE. Herb Caen addresses at the Mechanics' Institute Library on December 12, 1984. In his column on January 12, 1969, Herb Caen wrote these words about San Francisco, but they seem particularly relevant to the Financial District: "On foggy nights, when memories grow suddenly sharp in the gloom, you know the old city is still around you, just below the surface, an Atlantis on the Pacific. Maybe it's the foghorns calling mournfully to each other, the only voices still around that evoke the swish of the paddlewheels on ghostly ferries. Or, barely visible in the midst, a cable car disappearing over a hill on its plunge into yesterday . . . On a long January night in the quiet city (just before it stops being late and starts to get early), the ghosts begin dancing again, atop the creaking ferry slips, through the steel bones of cable car lines that were buried without funerals. Bits and pieces remain, the leftover pieces of a jigsaw puzzle we could never quite fit together." (Courtesy of Bob David.)

BIBLIOGRAPHY

Most of the information about the companies mentioned in this book was supplied by those companies or researched at local historical archives. Information about the Mechanics' Institute was supplied by the Mechanics' Institute Library.

Beebe, Rose Marie and Robert M. Senkewicz. *Lands of Promise and Despair.* Santa Clara and Berkeley, CA. Santa Clara University and Heyday Books, 2001.

Brechin, Gray. *Imperial San Francisco.* Berkeley and Los Angeles, CA. University of California Press, 1999.

Briscoe, John. *Tadich Grill: The Story of San Francisco's Oldest Restaurant, with Recipes.* Berkeley, CA. Ten Speed Press, 2002.

Bronson, William. *Still Flying and Nailed to the Mast: The Extraordinary Story of America's Boldest Insurance Company.* Garden City, New York. Doubleday and Company, Inc., 1963.

Browning, Peter. *San Francisco/Yerba Buena: From the Beginning to the Gold Rush 1769–1849* Lafayette, CA. Great West Books, 1998.

Charles Hall Page and Associates, Inc. *Splendid Survivors: San Francisco's Downtown Architectura Heritage.* San Francisco, CA. California Living Books, 1979.

Deleon, Richard Edward. *Left Coast City: Progressive Politics in San Francisco, 1975–1991.* Lawrence, KS. University Press of Kansas, 1992.

Fradkin, Philip L., *The Great Earthquake and Firestorms of 1906.* Berkeley and Los Angeles, CA. University of California Press, 2005

Kaapcke, Wallace L. "General Civil Practice—A Varied and Exciting Life at Pillsbury, Madison and Sutro," an oral history conducted 1986–1988 by Carol Hicke, Regional Oral History Office, The Bancroft Library, University of California, Berkeley, 1988.

Lavender, David. *Nothing Seemed Impossible: William C. Ralston and Early San Francisco.* Palo Alto, CA. American West Publishing Company, 1975

Olmsted, Nancy. *The Ferry Building: Witness to a Century of Change 1898–1998.* San Francisco, CA. Port of San Francisco, 1998.

Richards, Rand. *Historic San Francisco: A Concise History and Guide.* San Francisco, CA. Heritage House Publishers, 2005.

Roseman, Janet Lynn, Birmingham, Nan and Dorrans Saeks, Diane. *Gump's: Since 1861.* San Francisco, CA. Chronicle Books, 1991.

Sutro, John A., Sr., "A Life in the Law," an oral history conducted 1985–1986 by Sarah Sharp, Regional Oral History Office, The Bancroft Library, University of California, Berkeley, 1986.